MW00831769

HOW TO DRAW
MANGA
Computones

Vol. 3

CD-ROM Serial No.
CTWM30-300444079

HOW TO DRAW MANGA:
Computones Vol. 3
Mecha
by Hideki Kakinuma

Copyright © 2005 Hideki Kakinuma (Darts Co., Ltd.)
Copyright © 2005 Graphic-sha Publishing Co., Ltd.

This book was first designed and published in 2005 by Graphic-sha Publishing Co., Ltd.
Sansou Kudan Bldg., 4th Floor, 1-14-17 Kudan-kita, Chiyoda-ku, Tokyo 102-0073, Japan.

Original cover design and text page layout: Shinichi Ishioka
English translation management: Língua fránca, Inc. (an3y-skmt@asahi-net.or.jp)
Planning editor: Masahiko Satake (Graphic-sha Publishing Co., Ltd.)
Publishing coordinator: Yoko Ueno (Graphic-sha Publishing Co., Ltd.)
Project management: Kumiko Sakamoto (Graphic-sha Publishing Co., Ltd.)

All rights reserved. No part of this publication may be reproduced,
stored in a retrieval system, or transmitted in any form or by any means,
electronic, mechanical, photocopying, recording, or otherwise,
without the prior written permission of the publisher.

First printing: September 2005

Collaborating Artists:	Masashi Katahira(ARMIK CO.,LTD.)
	Kouichi Mitaka
	Kouji Nakakita
	Makoto Iwasaki
	Imove CO.,LTD.
	Daisuke Inoue
	Toshio Ban
Cover Illustrator:	Takumi Matsumae(TENKY CO.,LTD.
Special thanks to:	Yutaka Murakami(M Create CO.,LTD.)

ISBN: 4-7661-1564-3
Printed and bound in China by Everbest Printing Co., Ltd.

HOW TO DRAW
MANGA
Computones

Vol. 3

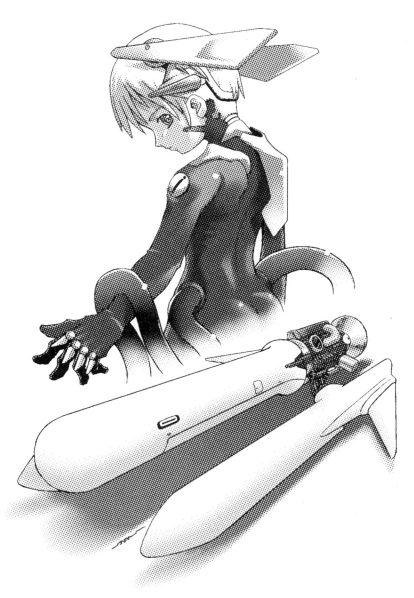

Table of Contents

Chapter 3: Manual..79

On the Techniques and Images Included and Introduced in this Book

Aside from a few exceptions, all of the original pieces in this book were created at a 600 dpi resolution in grayscale. Readers who will use the included CD-ROM and do their tone work on a computer are encouraged to do so on a machine that meets the indicated OS, CPU, memory, and hard disk requirements.

How to Use the Included CD-ROM

In order to use the included tone patterns CD-ROM, you must have at least one of the following software packages installed: Adobe Photoshop 5.0/5.5/6.0/7.0/CS or Adobe Photoshop LE 5.0; Adobe Photoshop Elements 1.0/2.0; Jasc Paint Shop Pro 7.0/8.0

Please use the CD-ROM after you have installed one of the above.

Metallic Means "Mecha"

The key point in making a robot look convincing lies in the metallic textures forming the robot. Attaching two dot tones of different densities to the robot to give it shading enhances the metallic feel. Using angular forms for the figure created a sense of volume and hardness.

Line Drawing

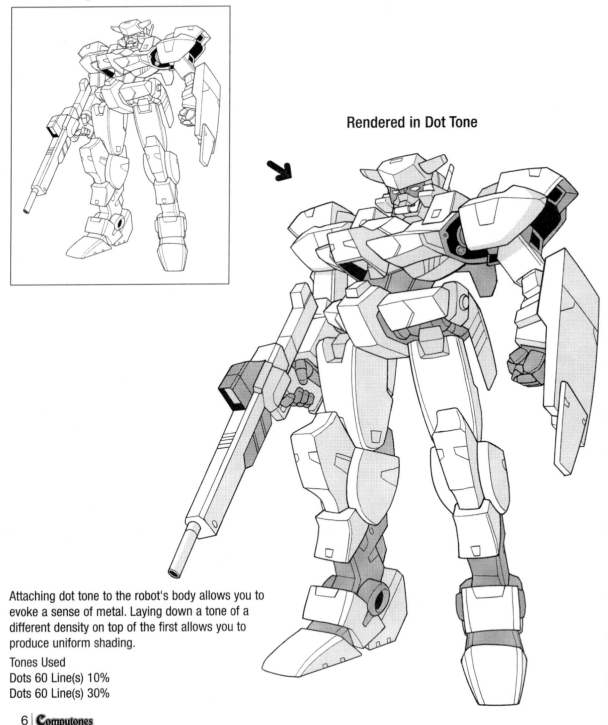

Rendered in Dot Tone

Attaching dot tone to the robot's body allows you to evoke a sense of metal. Laying down a tone of a different density on top of the first allows you to produce uniform shading.

Tones Used
Dots 60 Line(s) 10%
Dots 60 Line(s) 30%

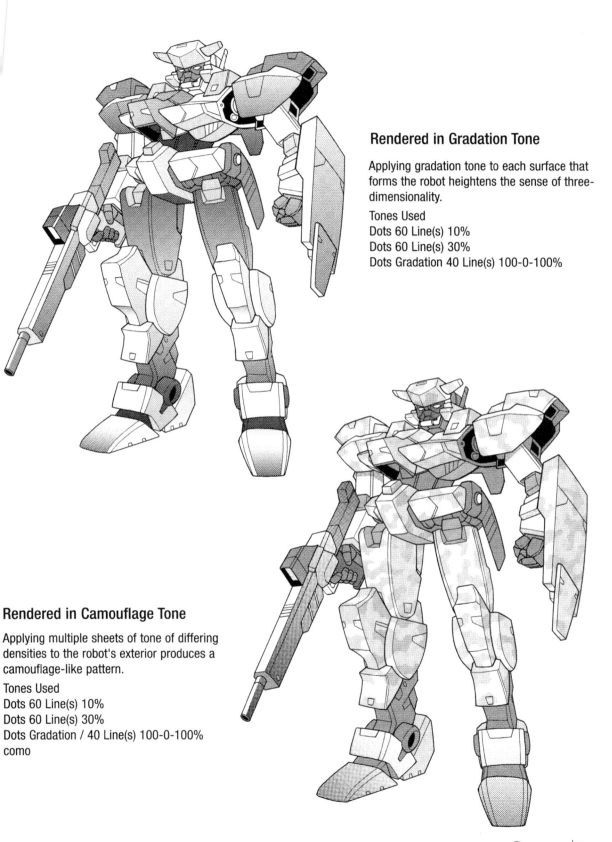

Rendered in Gradation Tone

Applying gradation tone to each surface that forms the robot heightens the sense of three-dimensionality.

Tones Used
Dots 60 Line(s) 10%
Dots 60 Line(s) 30%
Dots Gradation 40 Line(s) 100-0-100%

Rendered in Camouflage Tone

Applying multiple sheets of tone of differing densities to the robot's exterior produces a camouflage-like pattern.

Tones Used
Dots 60 Line(s) 10%
Dots 60 Line(s) 30%
Dots Gradation / 40 Line(s) 100-0-100%
como

Use Effect Tones for Professional-looking Backgrounds

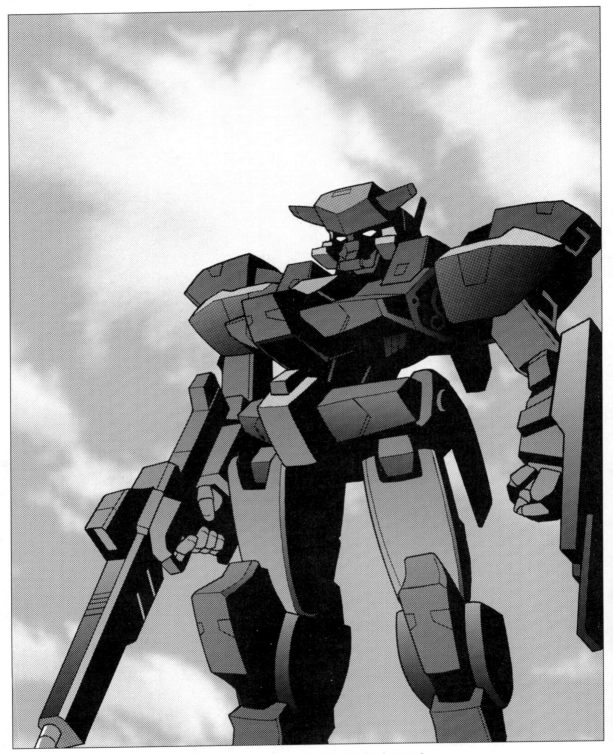

The example seen here shows actual cloud-patterned tone used in the background.
Even though the backlighting allows us to see the robot's full silhouette, we have a
sense of its enormous size.

Tones Used
Dots 60 Line(s) 10% / Dots 60 Line(s) 30% / Dots Gradation 60 Line(s) 100-0-100% / Cloud Tone 03

Chapter 1

Mecha Tone Work
Basic Tone Work

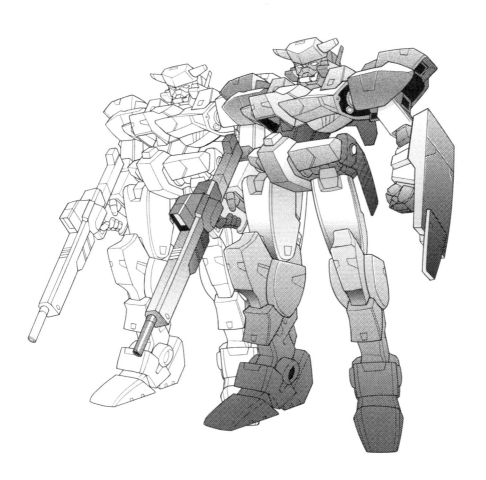

Tone Makeup and Effects

The ABCs of Tone

Tone is one of the most frequently used materials in manga and is a valuable one at that. Simply applying layered tone to a figure or to background allows you to enhance the look of three-dimensionality in your work. Of the array of tone patterns available, dot tone is the most commonly used. Tone may also be used to portray fabrics and materials and is used on robots to evoke a metallic feel.

The most common tone used for mechanical and synthetic objects is Dots 60 Line(s) 10%.

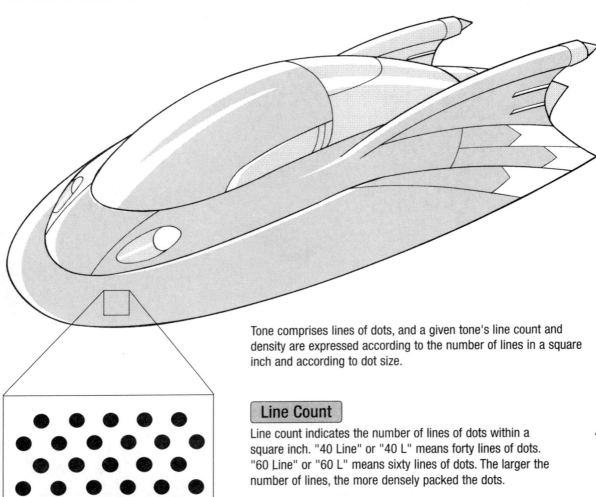

Tone comprises lines of dots, and a given tone's line count and density are expressed according to the number of lines in a square inch and according to dot size.

Line Count

Line count indicates the number of lines of dots within a square inch. "40 Line" or "40 L" means forty lines of dots. "60 Line" or "60 L" means sixty lines of dots. The larger the number of lines, the more densely packed the dots.

Density Percentage

The density percentage refers to the percentage of white to black within a square inch. The larger the percentage, the darker the tone is.

Point

The popular dot tone used for mechanical and synthetic objects is 60-line, 10%, which provides dots that are not overly tiny and a shade that is not too dark.

How to Use the Line Count and Density Percentage

Dot Tone with Small Dots

These tones produce a metallic look and enhance the sense of three-dimensionality.

Tones Used
Dots 60 Line(s) 30%
Dots 60 Line(s) 50%

Dot Tone with Large Dots

At first glance, this seems a rather rough pattern, but it allows you to produce more clearly delineated shadows.

Tones Used
Dots 20 Line(s) 10%
Dots 27.5 Line(s) 10%
Dots 30 Line(s) 10%

Tones of High Densities

High densities increase the range of shades the artist might use as "solid black fill." Here, it enhances the sense of three-dimensionality. At the same time, high densities create associations with hue, and here it has been used to "color" the vehicle.

Tones Used
Dots 70 Line(s) 10%
Dots 75 Line(s) 10%
Dots 80 Line(s) 10%

Patterns Other Than Basic Dot Tone

Tones come in a wide variety, designed to suit different uses.

A Gradation Tone

Gradation tone is used for rounded metallic forms and to suggest depth.

B Sand Tone

Sand tone is used to represent roads and other rough surfaces.

C (Cross) Hatching Tone

Hatching tone is used to suggest the plant foliage and to produce darker shadows.

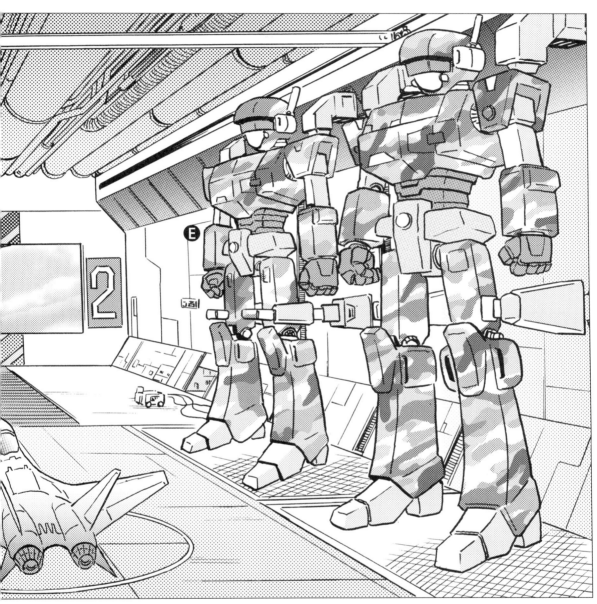

D Lined Tone

Lined tone is used to evoke a sense of speed and as a visual pattern.

E Patterned Tone

Patterned tone is used to represent fabric prints and motif designs.

F Special Effects Tone

Special effects tone is used to raise the intensity of scenes showing explosions, raging fires, etc.

Applying Tones on the PC

Previously, tones had to be applied by hand. But now, we can use computers to greatly reduce the time and effort it takes to use tones, and the range of tone expressions has greatly increased. First, let's learn a little more about tones.

What's a "Tone"?

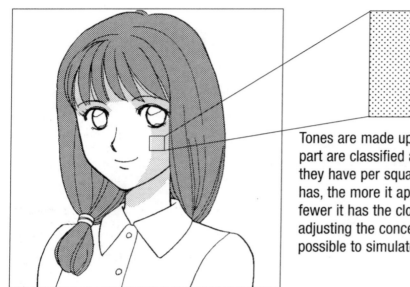

Tones are made up of black dots, and for the most part are classified according to how many dots they have per square inch. The more dots a tone has, the more it appears as a solid fill, while the fewer it has the closer it appears to white. By adjusting the concentration of dots, then, it is possible to simulate shades of gray.

Applying a tone on a PC

When tones are applied on a PC, not all the work is done on a single illustration. Rather, a separate layer is prepared atop it, and all the tone work takes place there. This makes changes and adjustments easier later on.

Layer 1: The main lines have been drawn with the Pen.

+

Layer 2: The tone layer.

Stack them up...

Make a layer just for applying tones, OK?

Stack them and the image is complete

Try using Computones!

Preliminary check! Are your PC and graphics applications ready to go?

In order to use Computones, you of course need a PC. However, if you have not installed any of the major graphics applications (such as Photoshop), then you cannot use it. Install Computones after you have made sure the graphics application you are using is compatible. The installation process is explained in detail in the manual, starting on page 122.

System requirements:
- Windows
CPU: 500 MHz Pentium3 or better (1GHz Pentium4 recommended)
Memory: 256MB or higher (512MB recommended)
OS: Windows98, ME, SE, 2000, NT, XP

- Graphics Applications (one of the following)
Photoshop 5.0/5.5/6.0/7.0/CS
Photoshop Elements 1.0 to 2.0
Paint Shop PRO 7.0/8.0

1 Draw your illustration directly on your PC or scan one in.

Point: Whichever method you use, make the actual size of your image 600 dpi or 300 dpi and set the color mode to grayscale.

2 Open your image with a graphics application.

Point: You open a file by choosing File → Open... and selecting a file.

3 Select the area to which you want to apply a tone.

Point: Use the Magic Wand from the Tool Palette to select an area for your tone, such as hair or the lower neck. If that selects too much of your image, then go back and do it by hand with the Lasso Tool. By holding down the Shift key you can freely select as many areas as you like.

- We will introduce a technique for deft area selection on the next page.

4 Start up Computones and apply a tone.

Point: Once you have selected an area, click on Filter → Computones in Photoshop, Photoshop Elements, or Paint Shop PRO to start Computones.

By clicking on whichever tone you like from among those displayed in the album on the right side of your screen, you can see what your image would look like with the tone applied. If you like what you see, then click OK to return to your graphics application.

5 Save your image.

Point: Save your image after you have finished applying tones to all the areas that need it. If you save your image in the PSD format, which can save your image data as it is while you are working on it, then you can easily modify it later. You might change to another format after consulting with a printing company later on.

Tone Application Fundamentals and Area Selection Techniques

By using the Magic Wand Tool, Computones can easily apply a tone to your image. However, if there are any breaks in your main lines, then whatever area is bound outside those lines will be selected, and the tone will not be applied properly. So, let's learn some techniques for easy, discrete tone application.

Now what!?

Since the hair main lines are not all connected, using the Magic Wand selects everything all the way in to the background.

Get used to using layers and applying tones.

1. Once you have opened your line drawing in your graphics application, duplicate Background layer to add a new layer (Fig. ❶). Call this new layer "Layer 1."

• How to duplicate a layer:
In Photoshop or Paint Shop Pro, open the Layers palette by selecting Window → Layers, click the button in the upper right to open a menu, and select "Duplicate Layer" (Fig. ❷).

2. On Layer 1, draw a line connecting all the hair lines together where their main lines end (Fig. ❸). This will close them off. Use the Magic Wand to select them (Fig. ❹).

3. Add a new layer, and call this one Layer 2 (Fig. ❺, Fig. ❻).

Go back to Layer 1 and copy the hair section. Move back to Layer 2 and paste the hair section you copied earlier (Fig. ❼).

How to make a new layer:
In Photoshop or Paint Shop Pro, open the Layers palette by selecting Window → Layers, click the button in the upper right to open a menu, and select "New Layer."

4. Call up Computones for the first time, and apply any tone you like (Fig. ❽, Fig. ❾). The hair tone is now complete. Delete Layer 1, where you drew your guidelines (Fig. ❿). The main lines return to their former appearance, and applied your tone. Now save your work as is.
Later, any alterations. To save the file as a normal EPS or JPEG file, you must "flatten" the layers you have added.

To do this, click on the button in the upper right corner of the Layer palette and select "Flatten Image" from the menu.

Point
By supplementing the lines on a copy and not tampering with the original image, there can be no accidental erasures or tone overapplications on it.

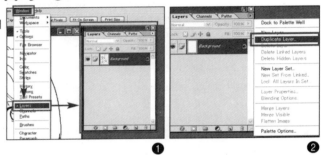

❶ ❷

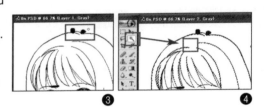

❸ ❹

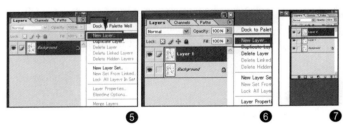

❺ ❻ ❼

❽ ❾ ❿

Applying shadow tones

Even when applying shadow tones to the cheek (or really, to any area with no lines), you still have to draw some lines to specify where the tone will be applied. But how do you get rid of those guidelines when you are done? Erase them little by little with the Eraser Tool? Going to such lengths is not necessary. Instead, you can use the techniques introduced previously to simply remove them.

1. Once you've opened the original image, duplicate the Background layer by selecting "Duplicate Layer" from the Layers Palette (Fig. ❶) and call it Layer 1. On Layer 1, draw guidelines with the Pen Tool around where you want your shadows to go (Fig. ❷). Then just as before, use the Magic Wand to select those areas.

2. Add a new layer, and call this one Layer 2 (Fig. ❸). Go back to Layer 1 and copy the shadows you have selected. Once you have moved to Layer 2, paste the shadow sections you copied earlier (Fig. ❹).

3. Call up Computones once again (Fig. ❺), and apply any tone you like (Fig. ❻). The shadows are now complete.

4. Delete Layer 1, where you drew your guidelines, and you are done (Fig. ❼). The main lines now return to their former appearance, and you have neatly applied your tone.

❶

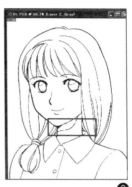

❷

❸

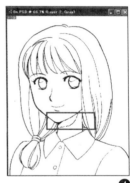

❹

❺

❻

Point

Adding guidelines to a copy lets you work without tampering with the original. Also, since you only copy the areas of the face that needed cheek shadowing, you save time that would otherwise be spent erasing unnecessary lines.

❼

Using Tone to Create a Sense of Volume

The Key to Making an Object Appear Solid Lies in the "Shadows"

We recognize a form as three-dimensional according to how that solid forms shadows. It is vital that you commit to memory what shapes shadows take, where they form, and the degree of darkness and translate these shadows into tone of a given darkness and line count.

Shadows That Form on a Box

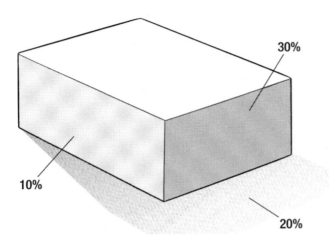

Here, I used a 10% tone to render pale shadows on surfaces touched by light and close to the picture plane. I used a 30% density tone for surfaces not touched at all by light. Merely adjusting the tone's density enhances the figure's sense of volume.

Shadows Formed by Bright Light

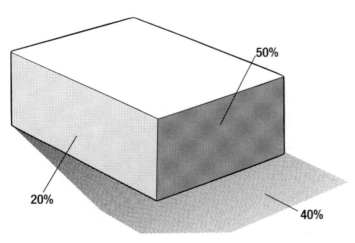

In the case of a bright light source, use darker tones for shadows to heighten the contrast between light and dark. Adding a shadow extending on the ground plane from the box makes the object more convincing.

Caution Regarding Dark Tone

Note that albeit rare, using tone of a 50% density or greater could result in the individual dots bleeding together [in the printing process], producing the same effect as if you had used solid black.

How Light Touches Uneven Surfaces and How to Render It

Rendered in Tones of a Uniform Density

In this composition, the light hits the bike in the front from the upper right. Apply the tone after imagining in concrete terms the direction of the light source. You will not be able to achieve much of a sense of three-dimensionality using only one type of tone.

Figure Rendered in Tone with Densities Adjusted to Reflect the Uneven Surface

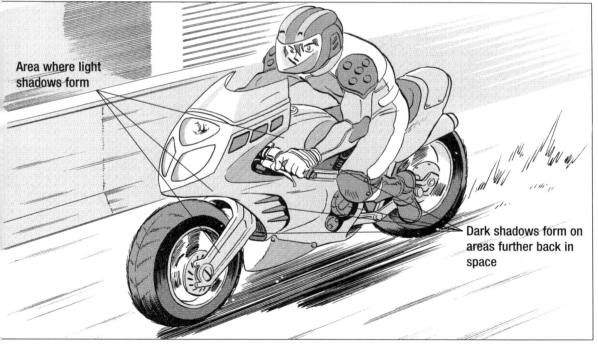

Area where light shadows form

Dark shadows form on areas further back in space

Use tones of differing densities to achieve visual balance in the shading. Here, successfully suggested texture in the wheels and the racing suit, enhancing the sense of volume. Added detailed white strokes around the wheels to create the illusion of dust kicked up, and in the background applied line tone to suggest speed.

Use Tone to Create a Sense of Depth

Apply tones of different densities to create illusion of depth.

A technique for creating the illusion of a large or immense object is to use darker tones for objects far from the picture plane and lighter tones for those close. Alternatively, reversing the foregoing rules of shading allows you to generate a sense of depth.

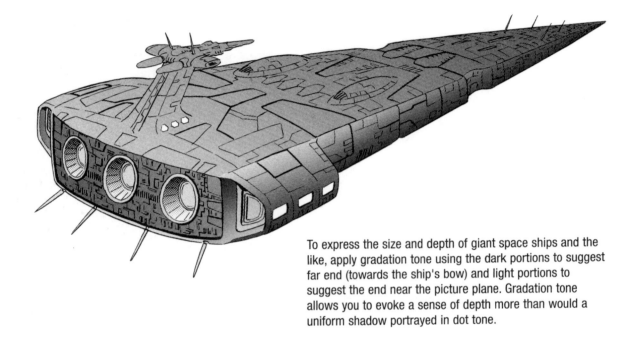

To express the size and depth of giant space ships and the like, apply gradation tone using the dark portions to suggest far end (towards the ship's bow) and light portions to suggest the end near the picture plane. Gradation tone allows you to evoke a sense of depth more than would a uniform shadow portrayed in dot tone.

Comparison of Tone Densities

Dot Tone

| 10% | 20% | 30% | 40% | 50% | 60% | 70% | 80% | 90% | 100% |

Gradation Tone

Light ←————————————————————————→ Dark

Gradation tone shows off the contrast of light and shade, allowing for effective shading.

Gradation tone establishes a difference in the degree of darkness, giving the figure a sense of weightiness.

Applying dark gradation tone to the unlit underbelly of a large tank weighing several tons provides a sharp contrast with the tank's bright upper surface, creating a sense of the vehicle's substantial weight.

The difference established between light and dark in objects near the picture plane and far objects evokes a sense of depth.

Use dark portions for distant areas and light tone for areas close to the picture plane when rendering objects of similar shape lined next to one another. This will establish a sense of depth for the overall composition and will make the objects appear to have distance between each other.

Gradation tone also allows you to create visual balance between light and dark.

When drawing solids lined in a row, maintaining a distinction between to which areas to allot dark tone and to which areas to allot light will allow you to portray a subtle sense of depth amongst the solids and as well as suggest miscellaneous objects in a row.

Layering Tone to Augment Portrayal of Textures

Layering tone allows you to produce gradated shading with more depth than you would achieve using only one sheet. This is known as "layering" or "overlapping" tone. Each tone is suited to particular genres or physical areas, and you need to distinguish between the different tones when you use them.

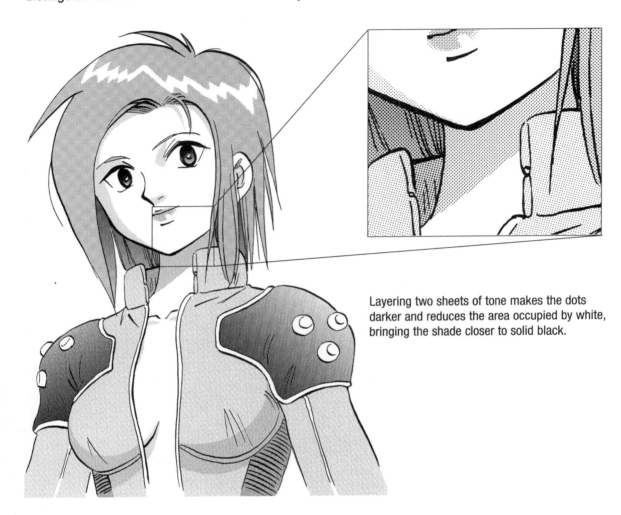

Layering two sheets of tone makes the dots darker and reduces the area occupied by white, bringing the shade closer to solid black.

Layering two sheets of dot tone with the dots misaligned produces solid black.

Slightly overlapped

Shifted halfway

Shifted so the dots do not overlap at all

Layering Two Different Tones

Layering tone allows a sense of the different shades of the robot's various parts.

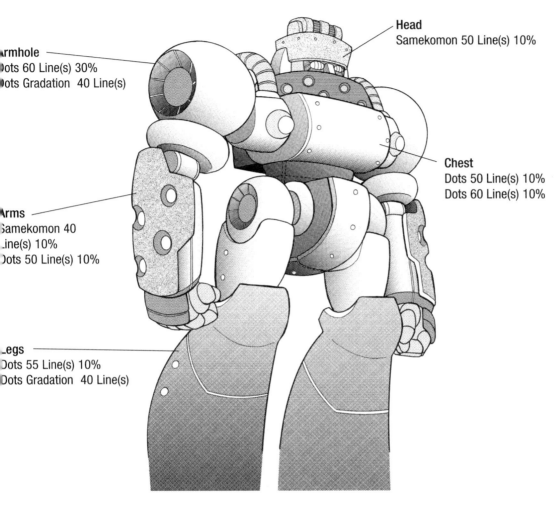

Armhole
Dots 60 Line(s) 30%
Dots Gradation 40 Line(s)

Head
Samekomon 50 Line(s) 10%

Arms
Samekomon 40
Line(s) 10%
Dots 50 Line(s) 10%

Chest
Dots 50 Line(s) 10%
Dots 60 Line(s) 10%

Legs
Dots 55 Line(s) 10%
Dots Gradation 40 Line(s)

Using Digital Layered Tone

After applying the first layer of tone to the drawing, select the target area and apply the second layer. Enlarge the image to double check the appearance of the two tones overlapping. You may use the layer function including in the graphic software to facilitate the process. The layer function duplicates the feel of a real animation cell by allowing you to view the image underneath, even if you are using layered tones. This means that even if you make a mistake, you can start over again from midway in the process. Refer to your graphic software manual for more information.

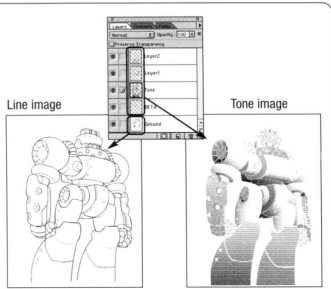

Line image

Tone image

Etching Tone to Create a Sense of Texture

Etching Dot Tone to Create Highlights

In order to make your artwork more realistic, use a brush to etch those areas of tone touched by light and use the white ground to portray light reflections. This technique is indispensable to creating highlights, luster, or a sheen.

Shading and Etching on a Cylinder

Line Drawing of a Cylinder

Cylinder with Tone

Cylinder with Etched Tone

You can create the sense of a solid simply by applying tone to the cylinder. However, using a brush to "etch" junctures between shadows or areas of blurred light and lightens these edges, giving the shadows a more natural feel.

Enlargement of Etched Area

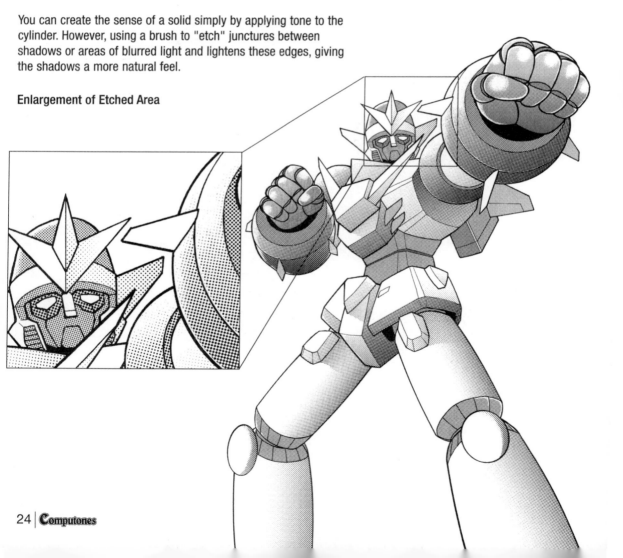

Assorted Etching Techniques

Photoshop and other graphic software include a "brush" function primarily to allow you to draw. We will now discuss techniques for using the brush tool to make tone appear to have been "etched." Depending on the software you use, it may contain a similar brush tool. If you do not have a brush tool, dry creating your own "brush" using the figure below as reference.

Dot Etching

This technique consists of aligning dots of different sizes and etching the tone using straight strokes. How light the etched dots become allows you to give subtleness to the look of the reflected light. Please note, however, that when etching curved areas, the etched lines may run into each other depending on the angles you use for the strokes. In such cases, shift the angle of the brush (i.e. the strokes).

Bokashi Kezuri ("Blurred Etching")

This is a technique whereby you blur the area surrounding the dots, gradually etching away dots that touch the brush. If you look at a photograph, you will see that the dots composing the image appear to fade gradually as if they were scattered etchings. Design factors such as the scope, length, and softness or hardness, etc. of the blurred region affect the results. Play around and see what results you get.

Expanded Bokashi Kezuri

Unlike the brush etching described above, this technique allows you to etch at one go an expansive area of dots. The blurred regions look like dust within a latticework shape, and modifying the strokes can produce any number of effects.

Portraying Luster

Tone work on a sphere can portray a sense of volume or luster on a surface. Applying gradation tone to a circle allows you to generate the illusion of three-dimensionality to some extent. However, spots of light reflected off the sphere's surface enhances the sense of luster and volume.

Sphere with a Lustrous Surface

Technique 1:
Gradation Tone with Borders Etched White

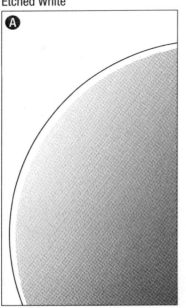

Technique 2:
Gradation Tone with Etched Light Reflections

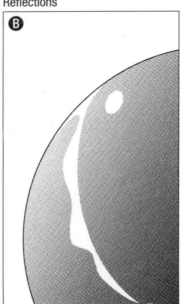

Technique 3:
Gradation Tone with Borders Etched

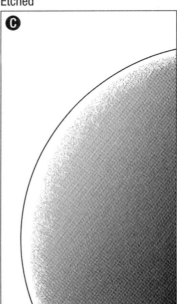

metallic sheen is indispensable if the robot has rounded forms. Please note, however, that
highlights should not be distributed randomly, but large, exaggerated reflections should be
added to those areas where you want to draw particular attention. For this robot, I
emphasized the reflections on the shoulders and feet, eliciting a look of rounded forms.

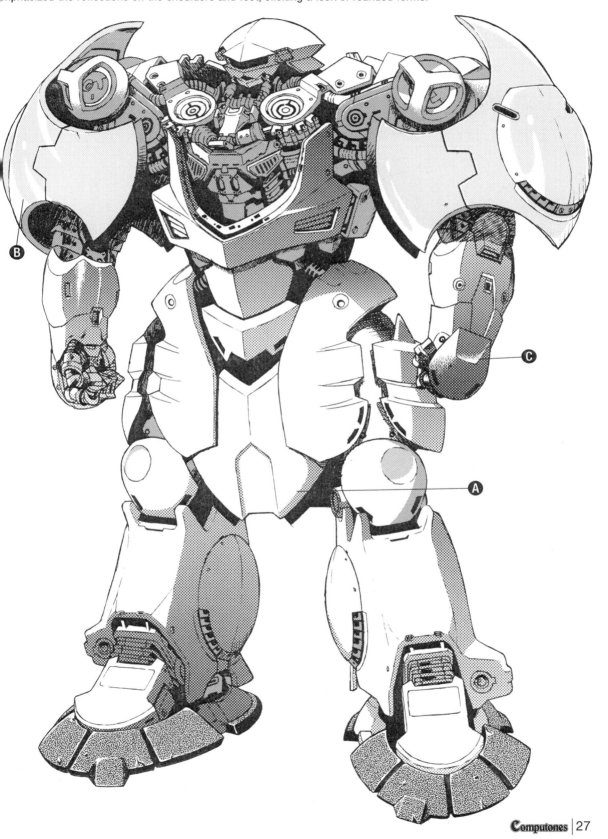

Portraying Metallic and Synthetic Armor

Robots are made from multiple materials such as iron and rubber. Try to picture the robot's various components when applying tone and complete the image by adding dot tones of varying densities to give it balance.

Technique 1: Portraying a Metallic Texture

Robots with complicated surface shapes may be suggested using the same techniques for portraying a sphere through making use of gradation tone and etched highlights.

Technique 2: Portraying Rubber

The key points in suggesting rubber lie in a matte finish and reflected light. Apply a slightly darkish tone to elicit the feel of the black texture. Use gradation tone instead of etching dot tone to portray highlights.

Technique 3: Portraying Reinforced Plastic

Plastic is a reflective material, so a light dot tone works well. To portray light reflections and a sheen, use a brush to blur edges, etching the tone lightly with scattered strokes.

is vital that you visualize the **texture** of each robot part's material and differentiate your
one application based on these materials. A uniform color (shade) fill or tone finish evokes a
ense of weightiness and volume.

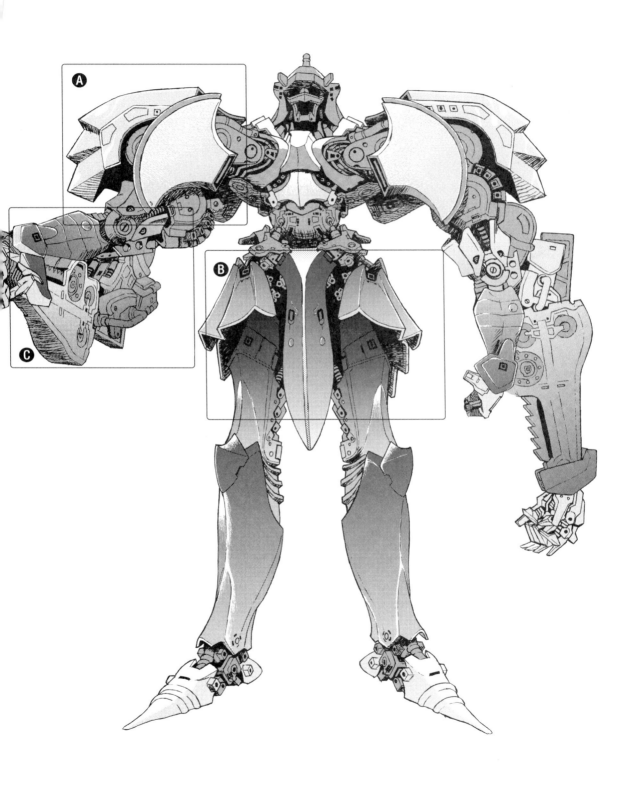

Portraying Round and Angular Forms

Use gradation tone to portray a variety of surface shapes. Most mechanical and synthetic objects are assemblages of surfaces, and, consequently, should be reproduced by exploiting the various techniques of expression to their fullest.

Using Tone to Suggest a Variety of Surfaces

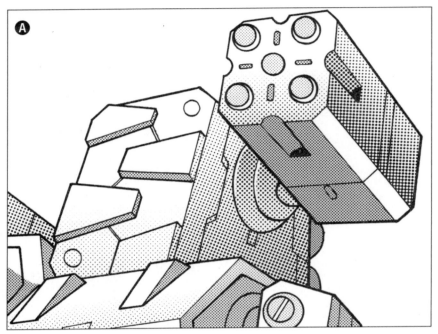

Technique 1: Heat-pressed Steel Sheet

Launcher are formed from angular, boxy shapes. Applying gradation tone to each surface will generate a sense of three-dimensionality.

Technique 2: Heels with Internal Engines

Etch reflected light in hemispheric shape of the underside of the foot and other round forms so that they are bordered in white. This creates the impression of a lustrous form.

Technique 3: Legs with a Sense of Weight

The shin has the curved surface of a cylinder, so I used gradation tone to suggest roundness and a sheen. Adding contrasting shadows allows the portrayal of depth and weight

To render a robot with a strong sense of weight, skillfully contrast white with dark to portray heaviness. Solid black projects the illusion of weightiness. Contrast the solid black with highlights to produce a three-dimensional look.

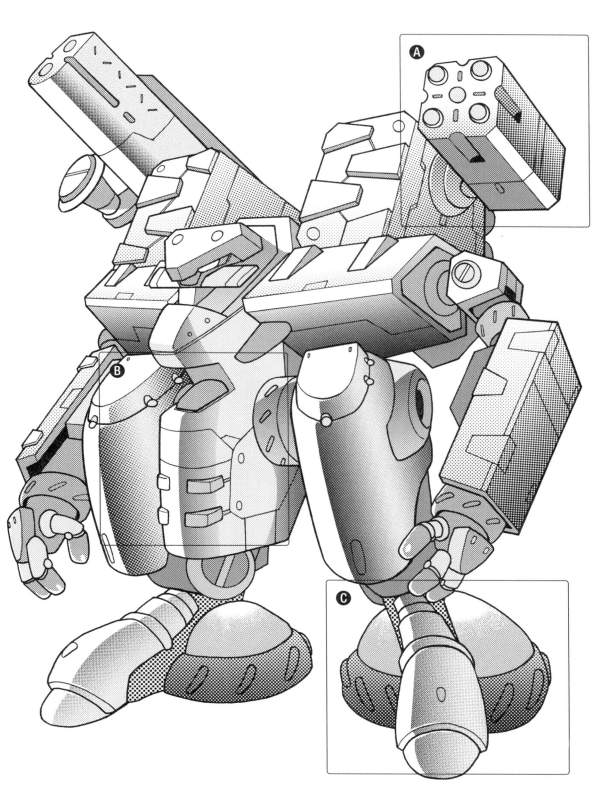

Portraying the Inside of a Car cabin

To portray this futuristic car formed of curved surfaces, draw the viewer's attention to reflections on the smoked windshield and the interior seen from beyond.
Apply gradation tone and etch for an effective finish.

Line Drawing of Car

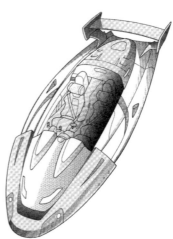

Technique 1: Tone Work on the Body

I used gradation tone to suggest the rounded form of the car's body. I drew the cabin's interior before applying the tone.

Technique 2: Portraying Shading on Smoked Glass

Apply gradation tone to portray the roundedness of the windshield. The more the roof moves in the direction of the bright frame, the darker it becomes visually. This alone allowed me to suggest the curved surface.

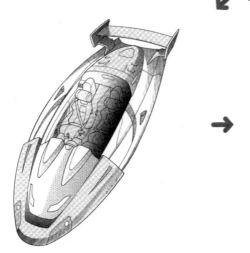

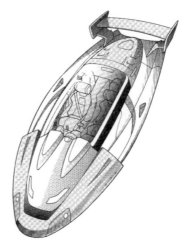

Technique 3: Rendering Highlights

Here, I laid dot tone over the light area of a gradation tone, lightly etching the top layer of dot tone to give the shading depth. I etched using straight strokes adhering to the windshield's surface.

Technique 4: Etching Highlights

After applying gradation tone, I etched the upper portion of the windshield to create reflected light. Adding definable highlights produces a more convincing image.

This is the sort of roundish car one finds in Sci Fi manga. Using gradation tone allows you to portray futuristic translucence accompanied by a crisp, clean glint. Etching to create highlights would heighten the sense of realism.

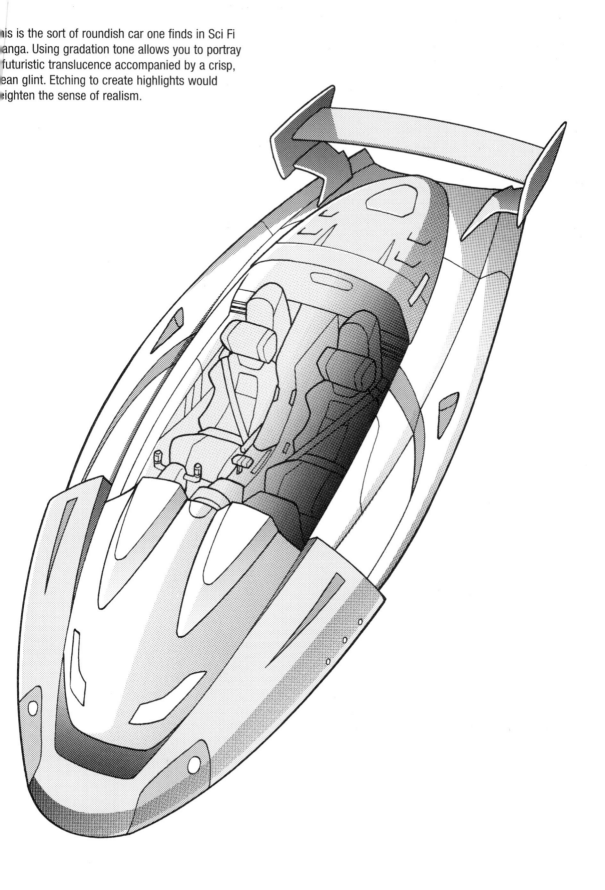

Portraying Soiled and Scratched Mechanical and Synthetic Objects

Let's take a look at the tone work process of a robot from beginning to end. Using tone work to portray soiling and scratches received during battle will make the image more realistic.

Robot from Birth to End

Newly Born Robot

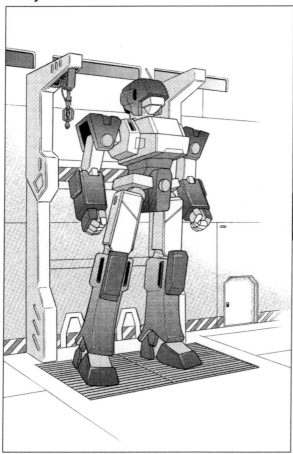

Battle Scene: Step I

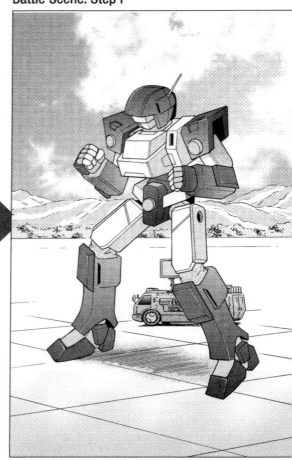

Portray a sheen by applying tone to a robot fresh off the assembly line. Use a different shade of tone for each surface of the unit to produce a shine indicative of a brand-spanking new machine.

In order to portray a scratched-up machine, you will need to do some preparatory work before applying the tone. Using unbroken lines, draw scratches on the robot's line drawing and then overlay with tone. By etching only "damaged" areas, the lines drawn will create the illusion of scratches.

Battle Scene: Step II

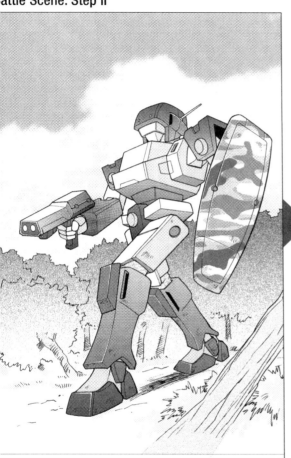

Imagine that the battle has grown even fiercer and add soiling to the robot's body. Using large strokes to blur regions intended to be "soiled" will produce roughly etched areas that look like soiling.

Breakdown and Full-Scale Destruction

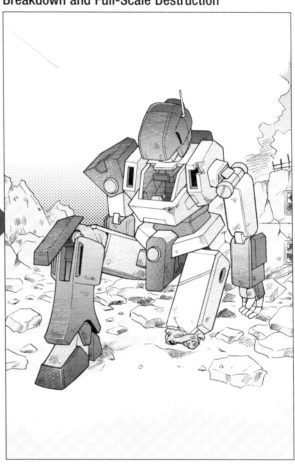

Use unbroken lines and solid black (i.e. black fill) to portray demolished robot parts, while adding etching all over the figure to suggest scratches.

Portraying Heavily Damaged Mechanical and Synthetic Objects

This illustration is of a robot whose armor has been destroyed and whose internal parts are now exposed. Exploit the textures and features of the robot's various components, such as the texture of uncoated, exposed metal, of internal soot, of the luminosity from the lights, of tubular cables, etc.

The Texture of Bare Metal

Etch dot tone to portray exposed metal. To portray a gritty, metallic texture, select the pencil tool and draw scratches here and there on the tone.

Portraying Internal Soiling

Apply a darkish gradation tone to portray interior shadows. This will draw areas close to the picture plane into contrast. Scattering detailed etching here and there will allow you to suggest scratches and soiling.

Lights

The left eye emanates a dim glow. Applying dot tone not to the eye's center but to the surrounding area and then using bokashi kezuri to blur provides a contrast with the pure white ground, making the glow from the lights more convincing.

Cables

I used a large random dot tone for the cable components to differentiate between the assorted materials. Etching the cables' surfaces allowed me to produce the matte finish of rubber.

I used gradation tone over the entire figure to generate a three-dimensional feel and amplified the sense of contrast by applying black fill to areas far from the picture plane. The more tones of differing shades are used to portray the various, fine components, the more successfully convincing the robot's complicated structure will appear.

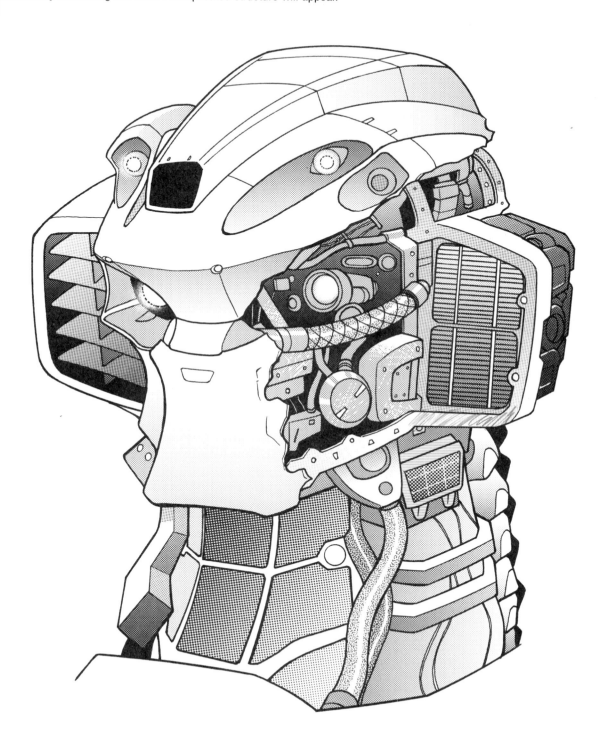

Portraying Creases in Uniforms and Suits

Movement-induced creases are vital to clothing portrayal. How creases form varies according to the material or fabric type, and you, the artist, must look observe clothing on a daily basis and investigate into its characteristics.

Direction of Pulling against the Fabric

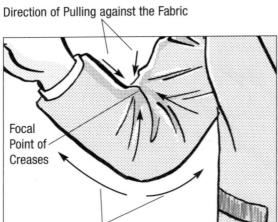

Focal
Point of
Creases

Where Tension Appears in the Arm

There are fixed rules to how movement-induced creases form. If a limb bends at the joint, the fabric is pulled with the joint forming the tension center, and the fabric pulling away from that center. Use the brush to etch lightly crease shadows.

Formation of Creases Owing to Arm Movement

Without worrying about the particular pose, identify where the movement-induced crease focal points lie and draw in the creases.

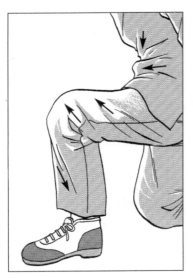
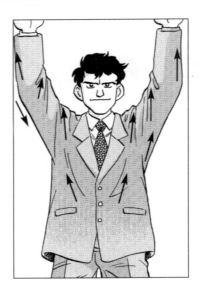
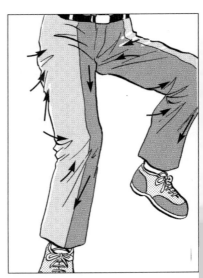

Natural Bagginess and Fit

Loose Clothing

To portray drooping in clothing apply tone in a wave-like pattern and etch. For space uniforms and helmets, apply gradation tone to portray smooth surfaces. Etch areas of reflected light for effective results.

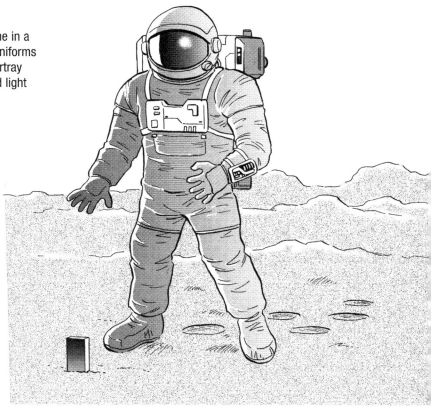

Snugly Fitted Clothing

Here, I used lined tone to portray the tight fit of a wetsuit and etched ripples of creases following the musculature. I applied gradation tone for the diver's hair to make it appear to flow back and up.

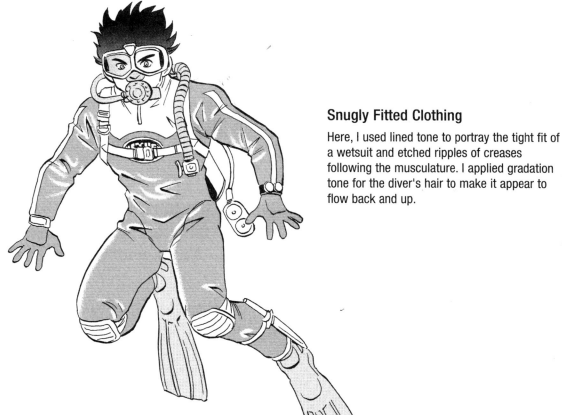

Structure

To draw a mechanical or synthetic object, you will need basic knowledge of the subject. You might be able to produce a convincing-looking object simply by looking and mimicking it visually. But some viewers may spot your lack of peripheral knowledge. Let's say for example an imaginary fighter jet. Very least need to know the following:

A

A. Simply drawing the canopy stuck on the fuselage somehow loses any sense of realism and makes the figure look like a toy.

B

B. Canopies are designed to be actually part of the fuselage in order to eliminate air resistance.

C
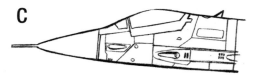

C. The fuselage is formed from attached sheets of treated metal, and close inspection will reveal numerous seams. However, noses often contain radar and are made of a resinous substance, and, therefore, have no seams.

D

D. Inspection manuals for fighter jets comprise tens of thick handbooks. However, the minimum "points of caution" are written ahead of time inside the fuselage. The fuselage contains detailed writing indicating the pilot's name, emergency procedures, places on the jet that must not be touched, etc. The United States military even has manuals for writing inside the fighter jets stipulating the type of font to be used, lettering dimensions, etc.

E

E. Because fighter jets are made from numerous types of metals, the surface luster on each panel has a different shade. Directly in front of the canopy, you find near-black, "anti-glare" coating designed to prevent glare from the sun.

F

F. Next, add soiling, scratches, and finally shading to help portray a sheen on the jet to finish.

If you show consideration to the above, you will achieve a sense of realism, even when drawing an imaginary fighter jet. If you follow these points integral to drawing a fighter jet, a tank, or a battleship, then you will be able to give imaginary weapons a convincing air.

Chapter 2
Advanced Tone Work

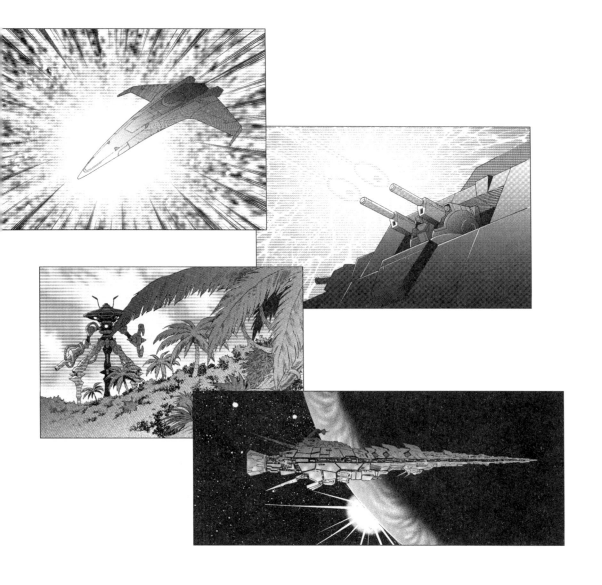

Using Tone to Suggest Colors

Using Shades of Tone to Portray Color

Tones come in light and dark shades, and tones may create the illusion of different hues by exploiting these differences in shade. For example, dark tones make give the impression of being red or blue. To learn what shade gives the impression of which color, take a black and white photo of your subject to see what shades the colors appear.

Camouflage Tone Palette

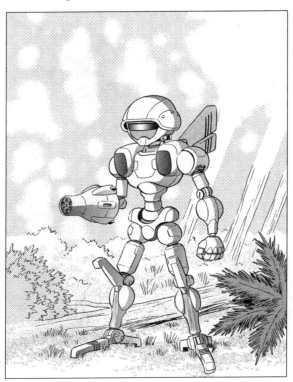

Jungle Palette

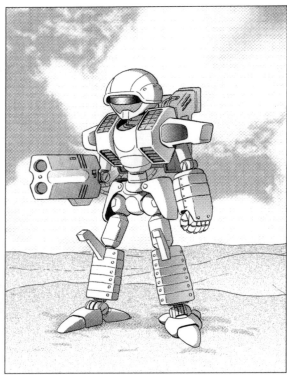

Dessert Palette

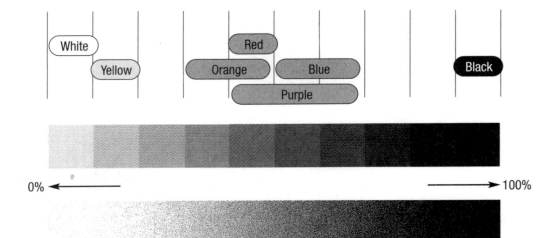

0% ← → 100%

Using Tone to Portray a Landscape

Using Tone to Portray Forests and Jungles

Use a random dot tone to portray the trees of a dense jungle. I imagined the green as a light tone of 5% density. In contrast, I opted for a dark tone of high density for the trees close to the picture plane, to create the impression of shadows darkening the forest.

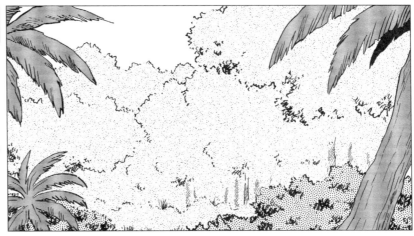

Portraying the Blue of the Ocean and Sky

Use a gradation tone of approximately 30% to portray the blue of oceans and the sky. Showing water spray on the waves and adding fine shadows to ripples will not only duplicate a blue tone, but will create the illusion of blue.

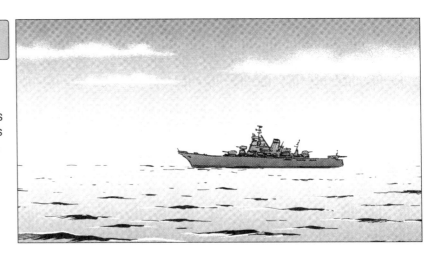

Portraying the Red Glow of Sunset

I used a 40% gradation tone to depict the red, setting Sun and a 30% gradation tone to portray the pattern of the glowing sky at sunset. As with the ocean, the key points here are to portray the flickering of the Sun and flow of the clouds using shading and etching.

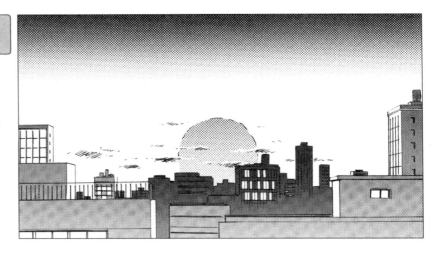

Mecha Tone Work I: Form

Distinct and Fuzzy Forms

The mechanical design can be considered a robot's lifeline, and what shapes the design is the form. It is essential that you keep the robot's design and form in mind when applying or etching the tone.

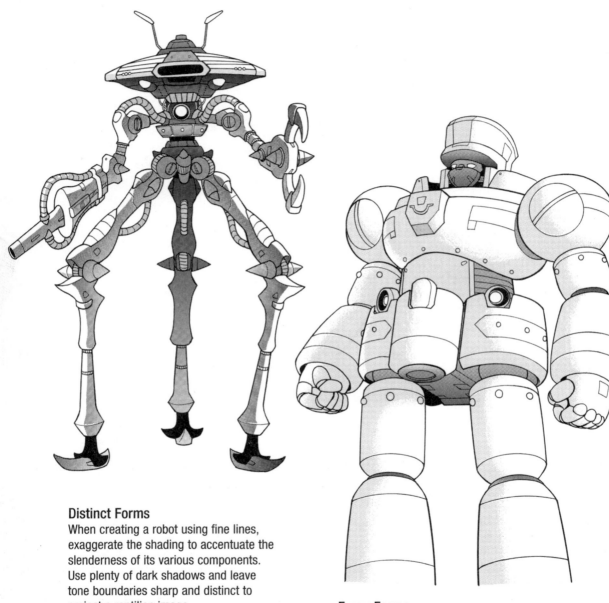

Distinct Forms
When creating a robot using fine lines, exaggerate the shading to accentuate the slenderness of its various components. Use plenty of dark shadows and leave tone boundaries sharp and distinct to project a reptilian image.

Fuzzy Forms
When creating a gargantuan, burly-looking robot, using an abundance of highlights will project the illusion of largeness. Apply tone to accentuate areas that jut out, such as the breastplate, etc. and lightly etch to blur. This will emphasize the largeness of the robot's parts.

How to Portray an Array of Forms

Form as Silhouette

The use of light becomes key when showing off silhouettes in dark scenes. Apply a dark tone to the overall, bathe the composition in light, and add highlights to robot components reflecting light. You may also portray light surrounding the figure to create the illusion of volume and draw out the silhouette.

Hazy Forms

To evoke a hazy atmosphere such as in rainy or misty settings, apply a large dot tone to the subject and etch following the direction of the wind. The tone should not cover the entire composition, but should be applied to individual portions as if concealing the subject to create the proper atmosphere.

Forms Bathed in Light

Using radiating lines creates a burst effect akin to light rays. Adding black fill to the effects sets off a contrast that makes the burst appear even brighter. Furthermore, radiating lines adds a sense of three-dimensionality and tension more than would limiting your tone usage to a single type.

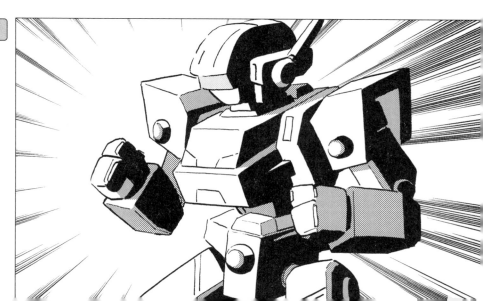

Mecha Tone Work II: Arms and Legs

Robot Joints

Robot joints are essential components in making your mecha look convincing. Maintain an awareness that the joints are assemblages of parts and distinguish its individual parts in your tone application.

Assorted Arms

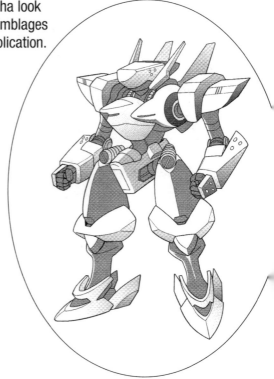

Thick Robot Arms

To render a round, thick arm, increase the area of reflected light on the arm's surface. This will emphasize the arm's size. In contrast, apply a darker tone to the joints than you did to the limb. This will create the illusion of being indented, making the joint appear tiny, thus accentuating the arm's girth.

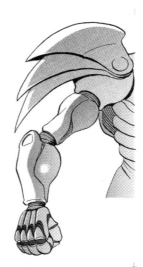

Butterfly Hinge-shaped Arms

This arm is able to fold at the shoulder with the elbow being reminiscent of a butterfly hinge in that it is capable of moving in only one direction. The part to accentuate is the butterfly hinge aspect, so apply a dark tone to the components and layer the tone to evoke the distinguishing features.

Humanlike Arms

Here we see a robot with humanlike joints, making it appropriate to shade it similarly to the flesh on an actual human arm. The joint is protected by rubber, so apply a tone darker than that of the limb itself to make the arm appear to dip in at the joint.

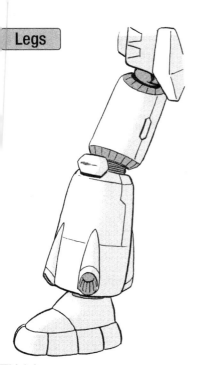

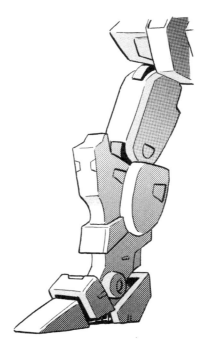

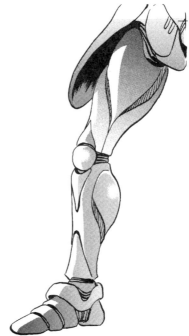

Thick Legs

These legs were designed to support a massive torso and are fundamentally triangular in form. Another key design feature is that different shapes were used to depict the hips than those for the knees. Add highlights with clearly defined boundaries and apply a tone to the joints that is darker than the rest of the limb to give the impression of a rounded leg.

Butterfly Hinge Ankles

When enlarging the joints, avoid applying the same tone that you do for the remainder of the leg. Applying a tone of a different density to distinguish the joint is a more effective approach. Adding shadows to solid robot parts that have depth, such as butterfly hinge-shaped joints, emphasizes the joint, pulling together the robot's pose compositionally.

Humanlike Arms

In the case of legs mimicking the musculature of a human leg, tone must be applied to follow the muscles just as you would when rendering a real leg. It is critical that you also distinguish between the thigh and the shin by shifting the direction of the gradation tone. Be sure to etch the joints to add light reflections, creating natural-looking highlights.

Using Joints to Make a Pose Sparkle

If you are having trouble achieving a pleasing composition or a satisfying pose for a robot you drew, a possible cause is the way you rendered joints. Robots and humans rarely stand in straight-upright, immobile manner, but rather their elbows and knees are turned either in or out.

Once you have determined what the pose will be, carefully draw the directions the shoulders, hips, elbows, knees, and ankles face. This will alone ensure a successful pose.

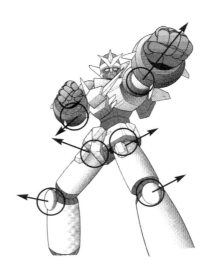

Mecha Tone Work III: Mechanical Objects and Metal

Portraying Metallic and Hard Textures

The trick to making a mechanical or synthetic object look convincing lies in material textures. Beginning manga artists may find some rendering techniques out of their range; however, using different tones to distinguish various components will allow neophytes to produce a convincing looking mecha.

Let's take a handgun for example. The frame is metal, the grip is resin, the hammer is brass, and the slide is, meaning that for each part, the material as well as that fabric's luster changes. Tone work reflects these different textures.

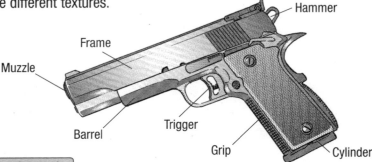

Hammer
Frame
Muzzle
Barrel
Trigger
Grip
Cylinder

Fighter Jet Cockpit

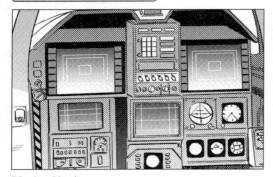

Display Monitor
This is an LCD monitor that displays images. Apply gradation tone, making the upper portion darker to draw out the sense that it is LCD, and use white for letters and images displayed.

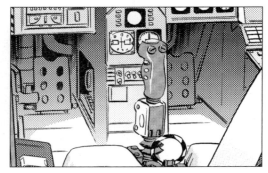

Console Panel
40-line gradation tone with moderately large dots to achieve a uniform sense of luster and a rough texture. Apply black fill to areas far from the picture plane to achieve visual balance.

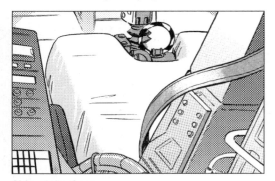

Side of the Seat
60-line dot tone for the side of the seat and etched the surrounding reflected light with soft strokes to blur boundary lines. The resulting image marks a soft contrast to the distinctly rendered panel.

Rear of Seat
The rear of the seat should be in shadow. Consequently, I selected a 40-line gradation tone and applied primarily the tone's darker portion. I also drew the seat askew to make it appear more like the real McCoy.

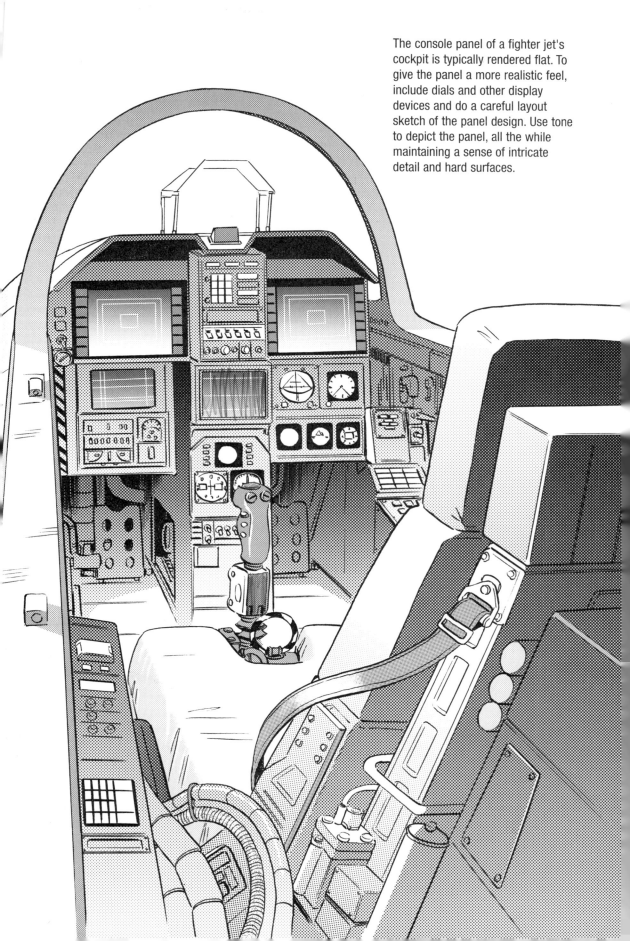

The console panel of a fighter jet's cockpit is typically rendered flat. To give the panel a more realistic feel, include dials and other display devices and do a careful layout sketch of the panel design. Use tone to depict the panel, all the while maintaining a sense of intricate detail and hard surfaces.

Mecha Tone Work IV: Windshields

Smooth Surfaces and Reflections

Gradation tone, which allows you to suggest glinting highlights, works well with a futuristic concept car with smooth, curved surfaces. Drawing reflected background details on the body enhances the sense of a gleaming car.

Incorporate Images

Consider what might be reflected in the body of a car: neighboring trees, buildings, people; a vast array of possibilities are out there.

Let's draw reflections into glass and mirror so that you can express sheen!

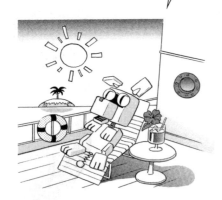

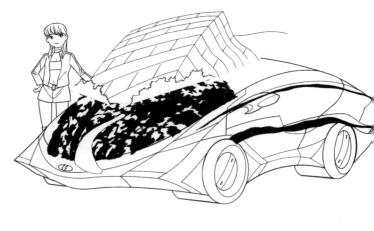

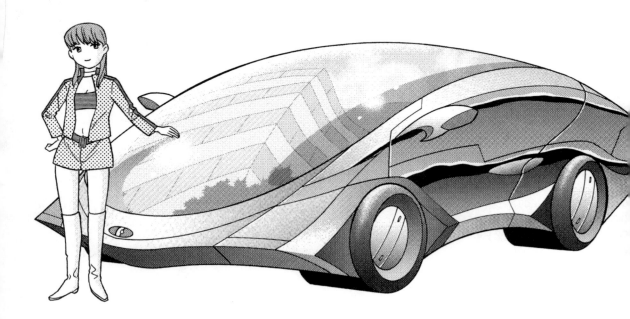

Techniques in Depicting Curved Surfaces and Reflected Light

Step 1: Using a Variety Tone for Different Items

Apply three tones of differing density to the front windshield. Blur the highlights' boundaries, visualizing reflected light while you work.

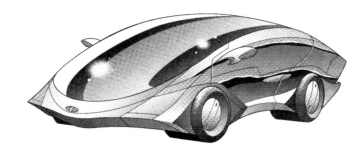

Step 2: Applying Cloud Pattern Tone

Next, apply cloud-patterned tone to the front windshield and etch to blur the reflected clouds. Etching clouds all over the windshield will achieve the most effective results.

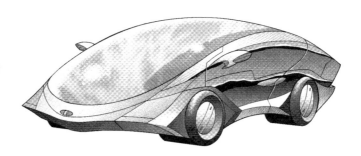

Step 3: Applying Tone to Create Foliage

one to the windshield and etch in the shape of tree foliage. If you are layering tone, shift the dots slightly to make the tone appear darker.

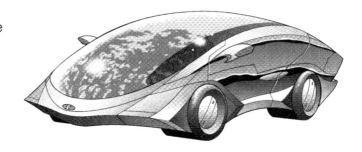

Step 4: Composing the Building Reflection

n Step 3, you created tree foliage. However, a windshield with buildings reflected might also be effective. As with the foliage, apply two types of tone, distinguishing between the different components when you apply them, add highlights, and lightly etch.

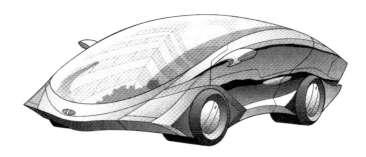

Mecha Tone Work V: Colossal Mechas

Portraying Size and Depth

Perspective drawing techniques as well as tone are used to suggest size and depth in giant robots, battleships, etc. Applying gradation tone to accompany the perspective will allow you to suggest a deeper level of shading and heightened sense of depth.

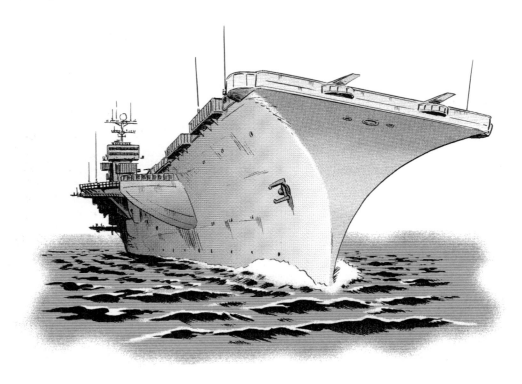

A Look at the Effectiveness of Tone

Line Drawing
Here we see a submarine drawn in perspective, but we do not have much of a sense of size.

Submarine Bow with Tone
In this figure, tone has been applied solely to the submarine bow. The tone gives the sub's front a heavier appearance, but we still have no sense of size.

Submarine's Side with Tone
I applied gradation tone to the submarine's side as well, giving the viewer a sense of its length. In addition, I layered the tone on the sub's nose, darkening it, and consequently projecting a more effective atmosphere.

Size Portrayed through Perspective

Make an effort to learn perspective and tone techniques so that you can master imparting you compositions with a sense of depth. The most common technique is to whiten objects close to the picture plane, while darkening those far from the picture plane, but the opposite technique also exists.

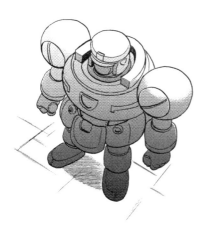

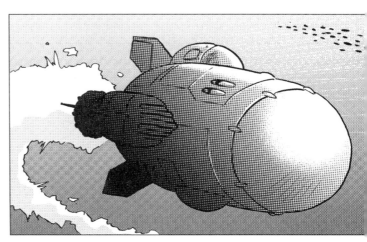

This is a downward field angle of the robot. Applying gradation tone so that the tone becomes darker in a downward direction portrays through the graduated darkening the distance and the length from the head to the bottom of the foot. Furthermore, either drawing shadows on the lower portion of the feet or applying tone allows you to project impressions of substantial size and weight.

This composition was executed as if sun was beating down on the submarine's upper half. Gradation tone was applied so that the submarine's upper half is white and the underbelly dark. Next, highlights were added to portions of the sub close to the picture plane to project a sense of direction and speed.

Contrast and Using Tones to Distinguish Items

Using the same tone to portray a long convoy of trucks allows you to indicate that the trucks comprising the convoy are all the same make.

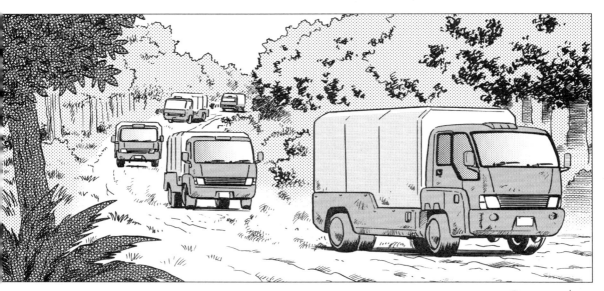

Mecha Tone Work VI: Fighter Jets

Using Tone to Portray Volume and Shading

Regular aircraft and space battleships are composed of detailed parts. To portray these complicated shapes using tone, not only must each component be differentiated from the others through the tone, but the direction in which the tone is applied is also critical. Be conscious that the subject is a solid when applying the tone.

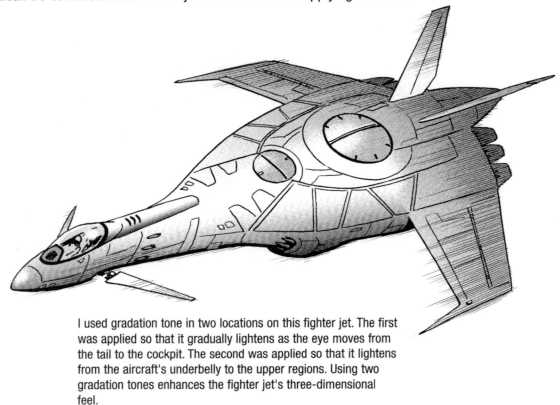

I used gradation tone in two locations on this fighter jet. The first was applied so that it gradually lightens as the eye moves from the tail to the cockpit. The second was applied so that it lightens from the aircraft's underbelly to the upper regions. Using two gradation tones enhances the fighter jet's three-dimensional feel.

Executing the Ground for the Fuselage

Use solid lines toward the back of the fuselage to evoke an illusion of speed. In addition, apply gradation tone to darken the rear to further heighten the sense of speed.

Apply black fill
The addition of the solid black pulls together the composition.

Apply lined tone
The addition of the lined tone imparts a sense of speed.

Apply tone to the aircraft.
The application of gradation tone from two directions projects a sense of volume.

Exploded Diagram of the Fighter Jet Tone Work

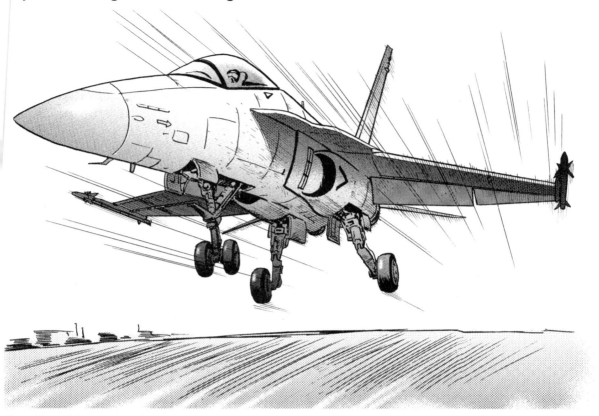

Four Renditions of a Fighter Jet

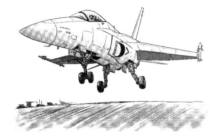

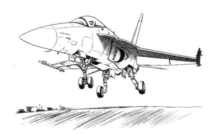

Fuselage Tone Work
Apply tone to the fuselage's underside to create shadows. Make the shading on the far wing darker than the rest, picturing it as not touched by reflected light.

Wing Tone Work
Produce shadows on the wing close to the picture plane. Apply a darkish tone as you did with the reverse side to cover the wing's overall underside with a dark shade.

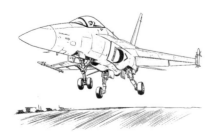

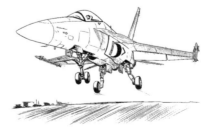

Portraying Dirt
Using solid lines to portray dirt. Applying tone from above the lines will create the illusion of soiling or scratches, projecting a realistic air. Not to draw too many strokes.

Solid (Hatching) Lines as Shading
I added speed lines in the form of solid lines, since the aircraft is supposed to be flying midair. Using scratchy strokes gives the image a rough look.

Mecha Tone Work VII: Missiles

Portraying Speed through Tone and Etching

Tones with radiating line patterns or speed line patterns often appear in compositions to portray speed. However, not only may these patterns be used to depict speed, but also merely applying such tone patterns enables you to draw the viewer's eye to the subject. This does not pertain solely to the missile discussed, but the same effects hold true when these tones are used with human and robots as well.

Missile Structure

The missile body is cylindrical.

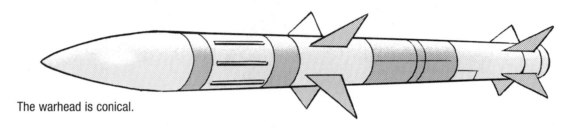

The warhead is conical.

Renditions of Missiles Using Tone

Missile with Radiating Lines

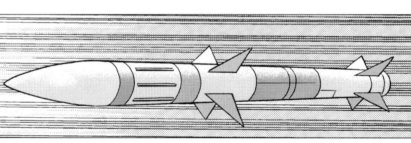

Missile with Speed Lines

Only drawing in three-dimensional is not enough method for expressing real "Speed"!

wheeeeeee!

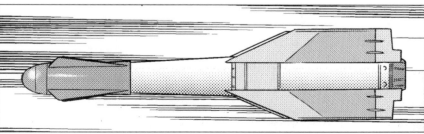

Missile with Diminishing Lines

Missiles with Etching

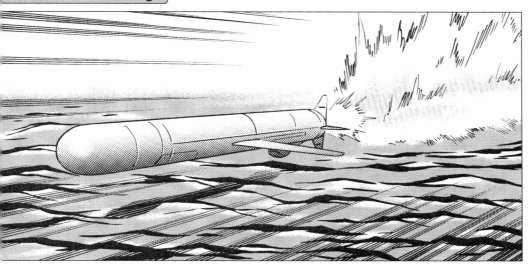

Hurtling Missile
Use the brush to etch the tone so as to create sprinkling water spray resulting from air pressure as the missile skims over the ocean's surface. Adhere to the direction in which the missile is flying when you etch, while following the shape of the waves.

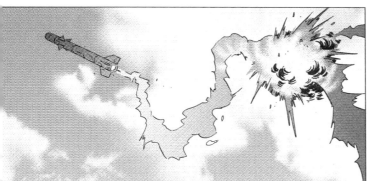

Launched Missile
This figure shows a missile that has just now launched. Using gradation tone to darken the missile body overall evokes the impression of the missile rocketing into the distance. Furthermore, adding tone to the spewed smoke underscores the smoke's intimidating appearance.

Missile Types
Drawing a manga missile so that it has some form of distinguishing feature will make it more memorable for the reader. Make an effort to imbue your missile with idiosyncratic qualities, including the size of the missile body; the presence of a tail and other identifiable features; whether the design has a high-tech, futuristic quality; etc.

Backlighting

Rendering Silhouettes in Explosion Scenes

By devising the stage setting so that an explosion far in the background creates a flash of light that renders the subject as a black silhouette, you are able to create a dramatic image. The following are key points in designing a composition.

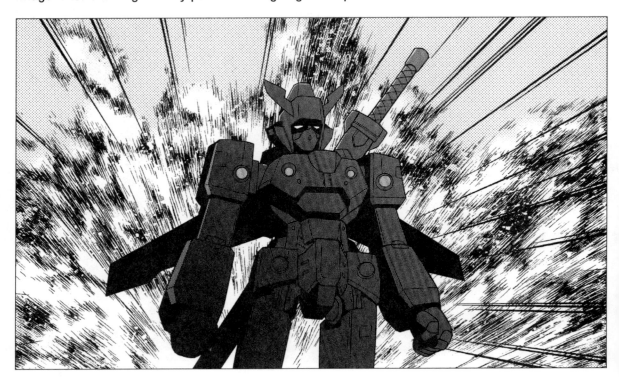

Key Point 1: Using Explosion Tone Effectively

Tone software packages always include some pattern that can be used in explosion scenes. Since merely applying this tone allows you to produce a dramatic image, it is fairly indispensable.

Key Point 2: Using Radiating Lines as Background

The ground behind the character comprises radiating lines. By using radiating lines as the secret ingredient in this composition, the viewer's eye is unconsciously drawn to the robot.

Key Point 3: Using the Silhouette to Enhance the Subject

The robot in this figure is represented solely as in silhouette, is not rendered in pitch black. By three different tones on the body, the robot's overall and details are not lost, even portrayed in a dark palette.

The Process

Step 1: Applying Explosion Tone

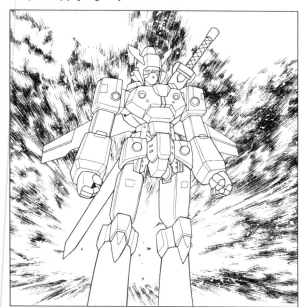

Apply explosion-patterned tone to the background behind the robot. Shifting the explosion's center just a bit off of the robot's position facilitates conveying the sense of an explosion taking place.

Step 2: Filling in the Silhouette

The silhouette takes form upon adding solid black and tone. The body is primarily rendered in tone, while nothing was added to the robot's eyes, which are backlit.

Step 3: Applying the Radiating Line Tone

Add radiating lines to the rear where the explosion is erupting. Here, the center point of the radiating lines should be positioned at the explosion's center to emphasize the terribleness of the explosion more than the robot.

Step 4: Etching the Tone

To finish, etch the area surrounding the explosion tone, using rough strokes to blur the tone's borders.

Flashes of Light

Using Radiating Lines Twice and Etching Tone

In this figure, we see what could be a spaceship instantaneously coming out of warp speed, etc. Using radiating lines in two locations: the background and on the spaceship's hull, heightens the sense of tension.

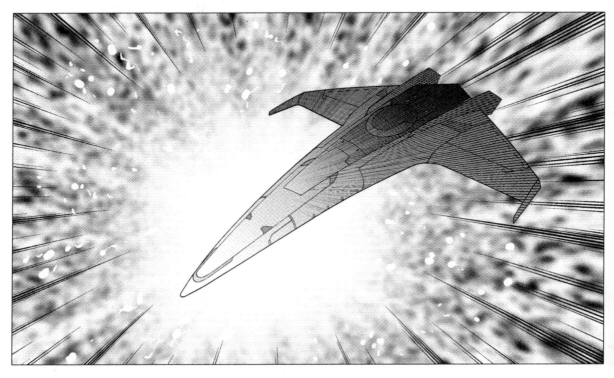

Key Point 1: Using Radiating Lines Twice

The radiating lines used in the background, also apply lines to the spaceship's hull. The viewer's gaze to the composition's center and underscores the sense that the spaceship suddenly appeared.

Key Point 2: Substituting Tone

The tone was originally designed to portray explosions. Even if you use a tone for a purpose other than its original intention, you can still achieve interesting results depending on the juxtaposition

Key Point 3: Spattering White

Highlights produced using the brush. Applying white "paint" produces a similar effect to etching the tone. Dribbling white specks around the spaceship's hull projects of the dynamism of warp speed.

The Process

Step 1: Establishing the Center Point

Determine where the center point of the radiating lines should lie so that you may lay down the tone. Rather than centering this point on the spaceship, instead shift it slightly to the side to achieve a more interesting composition.

Step 2: Applying Radiating Lines

Add radiating lines to both the background and to the ship's hull. To draw the viewer's attention to the ship, select a finely detailed pattern with many lines to apply to the hull. This make the ship appear dark.

Step 3: Applying Tone to the Background

Apply the explosion-patterned tone to the background, overlapping the radiating lines. The center point now appears to be a black hole from which the ship emerges.

Step 4: Adding White

Use the brush to add white to the explosion's center. Apply the white imagining that you are spattering white paint, producing the effect of scattered flecks of light. And, voila!

Exhaust Fumes

Portraying Exhaust Fumes and Thrusters

Here we see an image of a VTOL (Vertical Takeoff and Landing) aircraft, which uses powerful thrusters for jet propulsion, allowing takeoff and landing. To suggest intensely hot exhaust fumes and vapor, use gradation tone or etch using the brush. Adding radiating lines will give the viewer a sense of actually being there.

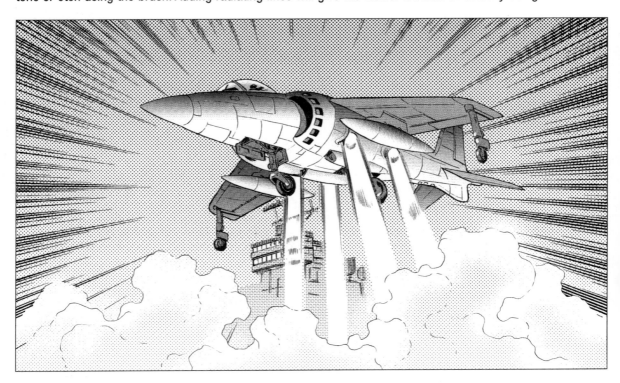

Key Point 1: Etching Smoke

Use the brush to etch to create the sense of vapor whirling about. Using rough strokes of the brush, etch randomly about the smoke's periphery.

Key Point 2: Shading the Aircraft

I used two types of shading for the VTOL aircraft: shadows on the body and on the wings, exploiting light and dark areas to evoke a three-dimensional appearance.

Key Point 3: Using Radiating Lines to Elicit the Sense of Being There

Even merely attaching the tone and then etching it with the brush will generate the look of an aircraft in flight. The addition of radiating lines allows you to produce a more realistic and striking scene.

The Process

Step 1: Composing the Background

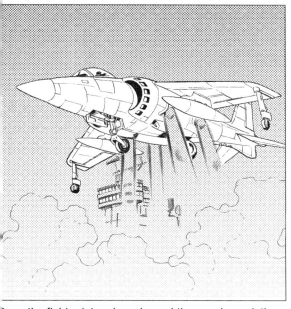

Draw the fighter jet and smoke and then apply gradation tone to the background laying it so that the darker portion is toward the top of the composition.

Step 2: Etching Smoke

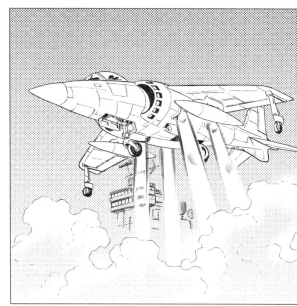

Keep the brush ready to blur the smoke's interior. Leave only the center unetched, etching the smoke in big, rough strokes.

Step 3: Shading the Craft's Body

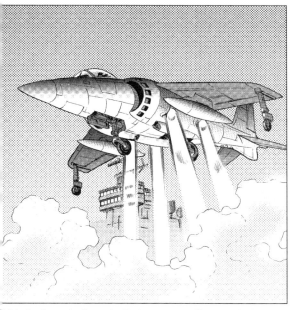

Add shadows to the robot's torso as well as gradation tone. Meanwhile, add different tones to the missile loaded on the aircraft, the tail, and other parts.

Step 4: Applying Radiating Lines

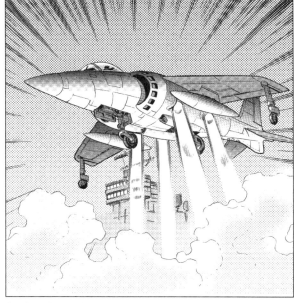

Apply radiating lines with the center point located on the craft's hull. The addition of the radiating lines truly gives the impression that the aircraft is in flight.

Bursts of Fire from the Gun Barrel and Firearms

Portraying Flashes of Light and Luminescence

This figure shows a cannon firing a burst of light. The flash at the time of the light burst and the burst's trajectory are portrayed using tone and etching.

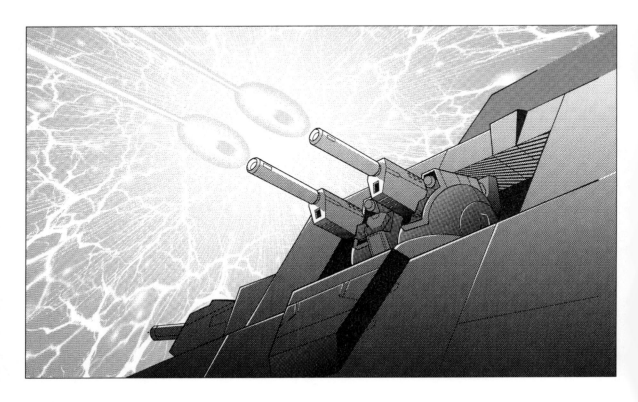

Key Point 1: Positioning the Center Point

To emphasize the force of the light burst, lay tone so as to bring the viewer's gaze to the artillery piece's muzzle.

Key Point 2: Solid Black Effects

Shading the cannon with black fill gives it a heavy appearance.

Key Point 3: Depicted Light Blasts

To achieve a sense of realism, the burst of light fired from the cannon should not follow a simple, straight trajectory, but should swell for an instant and then attenuate.

The Process

Step 1: Center Point Positioning and Tone Selection

Position the center point of the artillery piece's muzzle. Since the subject is a fired burst of light, opt for a thunderclap-patterned tone and align the center of the thunderclap with the muzzle.

Step 2: Applying Tone and Solid Black

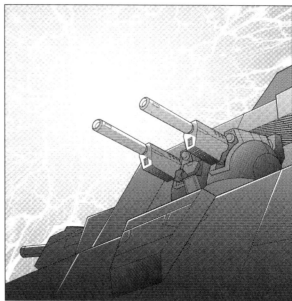

Apply tone to the cannon and then add black fill. Visualize the cannon becoming a shadow over the fired burst and cover the cannon in dark shades. Use particularly dark tone on the underside of the artillery and in crevices and projecting areas to create a sense of weight.

Step 3: Drawing the Trajectory

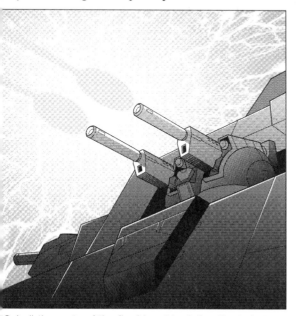

"Color" the route of the fired burst to define the trajectory. Next, use the brush to etch the "colored" regions.

Step 4: Etching the Burst of Light

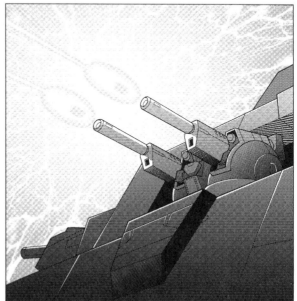

Add white to the regions just colored, thus portraying the flash of light's brilliance through contrast with the dark, "colored" regions. Also, etching in bold, rough strokes with the brush, blur the swell of the light burst near the muzzle to generate the look of having just been fired.

Explosions

Portraying Explosions Using Tone

There are various means of representing an explosion. Here, we will demonstrate how to create a scene with impact using explosion-patterned tone. The sample shows a huge mushroom cloud explosion detonating in the sky above the town.

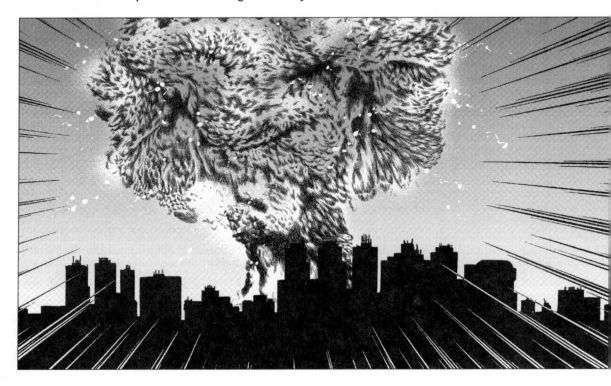

Key Point 1: Amplifying the Contrast

To portray the explosion's flash, I used a darker shade for the rows of buildings in the background, thereby heightening the light/dark contrast.

Key Point 2: Portraying Smoke

While the composition would have been acceptable with merely applying explosion-patterned tone, overlaying the explosion with dot tone and then etching it gave the smoke a heavy feel.

Key Point 3: Differentiating with Radiating Lines

White radiating lines reversing the appearance of normal radiating lines to create the fill burst pattern for the background buildings along street. Refer to the Computone Manual for more technique.

The Process

Step 1: Applying Explosion Tone

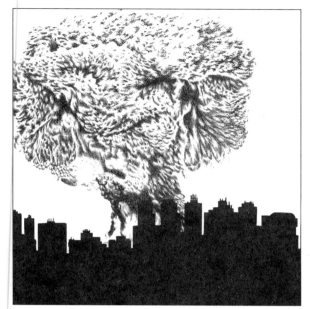

Maintaining a consciousness of achieving contrast, fill in the background buildings with black and then apply explosion-patterned tone to the background.

Step 2: Applying Radiating Lines

Align the center of the radiating line pattern with that of the explosion pattern, and cover the surrounding area with radiating lines.

Step 3: Etching Smoke

Apply gradation tone to the overall background and using the brush, etch to blur the smoke from the explosion. Etch around the outside of the tone, leaving the center untouched.

Step 4: Apply the Reversed Radiating Lines

Finally, flip over the radiating lines just used, thereby whitening the effect, and align with the black-filled background buildings. Following this process allowed me to encircle the entire explosion with radiating lines.

Scorched Earth

Portraying Smoke and Flames

Try to depict flames, an indispensable element to battle scenes, using tone. There are various methods of rendering tone, but let us examine in our discussion a combination of a subject and flames. In the example offered here, we have a robot standing in the center of raging flames.

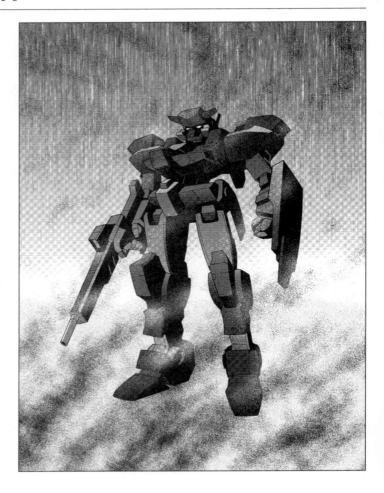

Key Point 1: Underscoring the Contrast with the Aircraft

Imagine this as a dark scene and select dark tones for the aircraft hull.

Key Point 2: Applying Different Tones to the Upper and Lower Portions of the Composition

After large-dot tone, overlay the first sheet with two different types tone, one for the upper and the other for the lower half of the composition. This will produce a devastated, scorched earth atmosphere.

Key Point 3: Rough Etching Technique

Etch the tone with the brush using whorl-shaped strokes. Etch the overall composition, moving the brush to create the illusion of smoke being lifted by a breeze.

The Process

Step 1: Applying Tone

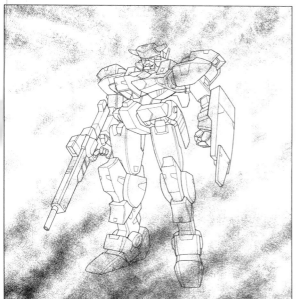

Use solid lines to draw the robot and lay scorched earth tone over the figure.

Step 2: Adding Tone and Shadows to the Robot

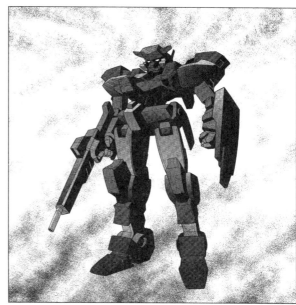

Here, I used 20% tone for the robot's front, 30% for its side, and then 40% for regions far from the picture plane, to create an overall dark composition, since "scored earth" has a dark sensibility to it.

Step 3: Layering Tone

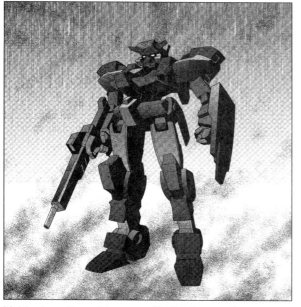

I laid rain-patterned tone over the background's upper regions. Smoke appears to coil around the robot's feet, permeating the surrounding air, while bearing down heavily on the robot's head.

Step 4: Etching the Overall Form

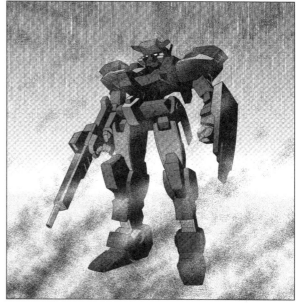

Lastly, I used the brush to etch the smoke, making it appear to encircle the overall figure. I set the brush tool to etch large, bold strokes, creating a spiral coiling around the robot.

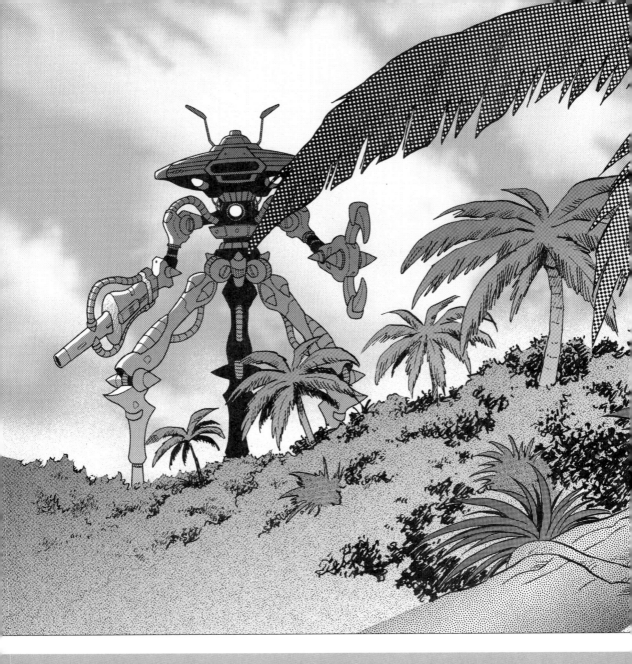

Key Points in the Techniques Used

Jungles

Three types of tone were used here to portray the foliage and the individual trees. By reserving the darkest shades for large leaves close to the picture plane, the overall composition became dark in atmosphere, which is contrasted with a bright sky.

Shading the Robot

Visualize the robot with backlighting, and use dark, blackish tones. Etch the boundaries, suggesting light surrounding the figure.

Scene Dramatization and Portrayal Techniques Part I
Forests and Jungles

This is a scene depicting an encounter with a robot in a jungle. The composition was rendered for impact, using tone work to create the illusion of a dense jungle, while creating the impression of a robot appearing out of nowhere.

Tones Used

Robot:
Dots Gradation 60 Line(s)
100-0-100%

Sky:
Cloud12

Leaf of coconut:
Dots Gradation 40 Line(s)
100-0-100%

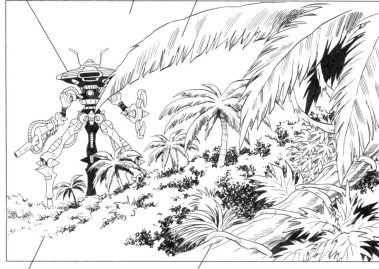

Jungle:
Dots Gradation 60 Line(s)
100-0-100%
Sand 35 Line(s) 10%

Tree:
Samekomon 50 Line(s)
20%

Etching Clouds
Lay two tones of differing densities on the sky. Then, use bokashi kezuri and blur boundaries to create clouds. Before beginning the tone work, make a decision as to which direction the clouds should flow.

Portraying Gloom and Using Solid Fill
Use black fill in between the individual trees. This will pull together the composition and evoke the sense of the jungle as a densely packed space.

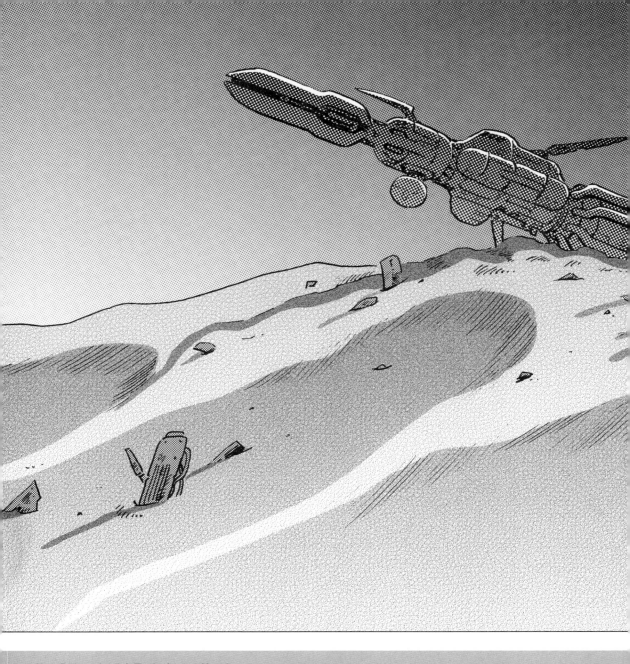

Key Points in the Techniques Used

Moonlight
Apply a layer of tone, and once again add tone to areas cut out and left white. Create a striking image, by using the brush to blur the border of the white area.

Crashed Spaceship
Apply a darkish tone to the spaceship, painting a lonely picture of the ship's wreckage rendered in silhouette. Solid fill added in between the various components and moonlight surrounding the ship constitute key points in rendering the composition successfully.

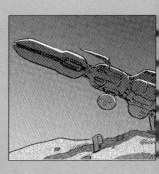

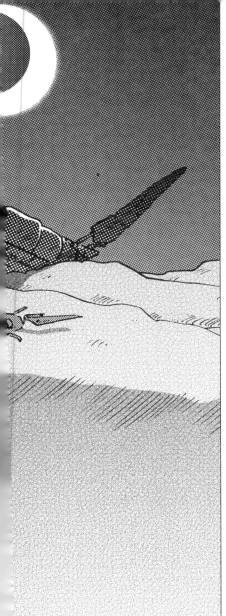

Deserts

To portray a desert, show a desolate landscape expanding across the composition. Use random dot tone, while adding gradation tone to impart modulation and depth on a gently sprawling landscape.

Tones Used

Night sky:
Dots Gradation 60 Line(s)
100-0-100%

Spaceship:
Dots Gradation 40 Line(s)
100-0-100%

The moon:
Dots Gradation 60 Line(s)
100-0-100%

Desert:
Sand Hatching Gradation 40 Line(s) 40-0-40%

Hatched Ground
It may be difficult to convey the impression of a desert using tone alone. Therefore, adding hatching in the form of solid lines to portray the gentle slope of a hill should enhance your descriptive capacity.

Deserts
Here, two types of random dot tone were used for the desert. A light random dot tone was used for surfaces touched by light, while a dark tone was used for areas in shadow. The light and dark shades create the illusion of an undulating surface.

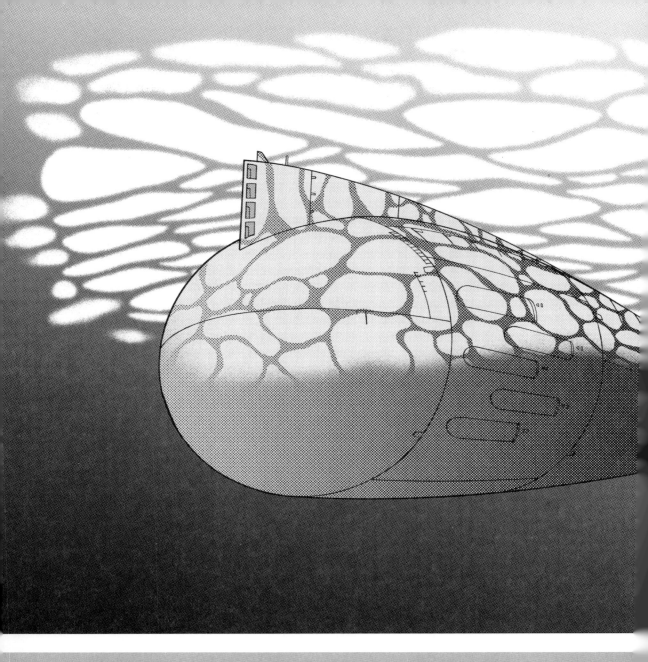

Key Points in the Techniques Used

Water Surface Pattern
To portray the Sun beating down on the sub through the clear water, apply gradation tone to the composition overall. Etch with the brush, blurring the borders of the gentle waves rocking in the water.

Reflections on the Hull
This figure shows ocean waves reflected on the submarine's hull. Tone has been applied to the submarine in a pattern mimicking the water's surface.

Scene Dramatization and Portrayal Techniques Part III
The Ocean

Here we see a massive submarine propelling through the water. The submarine skims the water's surface, and Sun's rays beating down on the ocean's exterior bathes the submarine in light. The transparent water and reflections of the submarine on the ocean's surface constitute key points for this composition.

Tones Used

Prow:
Dots 60 Line(s) 30%

Ocean:
Dots Gradation 60 Line(s) 100-0-100%

Submarine:
Dots Gradation 40 Line(s)
100-0-100%

Shadow made submarine:
Dots 60 Line(s) 10%

Black

Etching the Hull
Apply gradation tone to the hull with the tone becoming darker as the eye moves down. Use the brush to blur shape borders. Widen the area etched for the bridge, which is located far from the picture plane, and narrow the area etched as you approach the picture plane.

Portraying Depth
Applying the tone to the sub becomes lighter as the eye moves toward the picture plane, and the other to the water becomes darker as the eye moves toward the ocean's floor. A key point when applying the tone to the water is to lay beforehand at an angle.

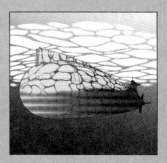

Space

The example seen here is a planet and gigantic space ship defined using tone. The twinkling of stars speckling the background and the glow of the planet are key points in generating a dynamic luminescence.

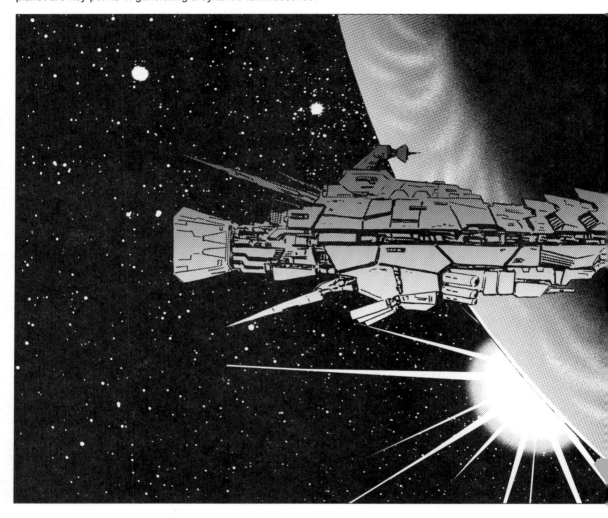

Key Points in the Techniques Used

Spaceship Detail

Since visual balance must be achieved in the varying degrees of darkness, and because the spaceship is the object that should be made the most prominent second only to the planet, opt for a tone that is lighter than the surrounding space but darker than the planet.

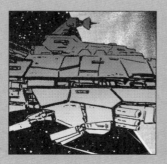

Sun Rays

Apply white to the black-filled background and using the brush, etch to create a softly indistinct blur, and finish by adding lines to suggest twinkling starlight. If you experience difficulty creating the lines for starlight by hand, radiating line tone is another viable option.

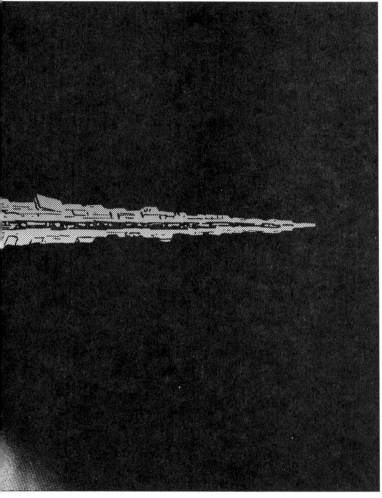

Tones Used

The tone is cut
down and the
cloud is made.

Space:
Dots Gradation 60 Line(s)
100-0-100%

Sun:
Dots 60 Line(s) 10%

Sun Rays:
Dots Gradation 60 Line(s)
100-0-100%

Planets

Fill in the planet'
silhouette with solid
black and apply
gradation tone to areas
touched by light. Use the
brush to blur shadow
borders. At this time,
open the setting for the
brush tool, and set the
ink volume to 70% This
will allow you to create
even softer etches than
previously.

Space

Space is primarily
rendered using black fill.
Use the standard pencil
tool to produce regular
and fixed stars, scattering
randomly sized flecks
throughout the
composition.

Realistic Parts

Mechanical and synthetic objects are a compilation of innumerable parts. However, despite the many parts, not a single one is without purpose. When intending to draw a close-up, including realistic detail to any degree will allow you to draw the object as up close as you deem necessary.

In Fig. A, which shows the full fighter jet, the landing gear is depicted as a single pole. However, a close-up of the landing gear reveals that it is actually made of hundreds of parts. These are apparatuses comprising the main shock absorption oleo struts, retractable gear, drag braces, shock absorbers, hydraulic oil pipes, electrical cables, disk brakes, and countless other parts. An even closer angle would bring even more tiny, complicated apparatus and screws into view.

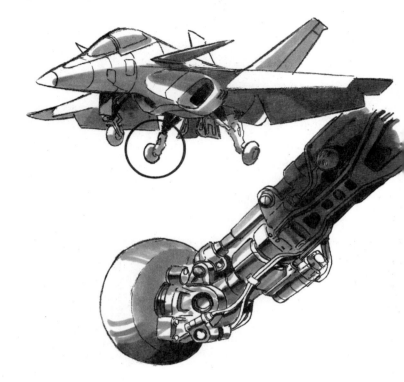

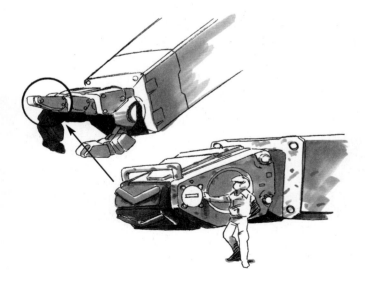

When designing an imaginary mecha, imagine the functions that this original mecha of yours might possess. The fingers of the 100-meter tall giant robot shown in Fig. B are not mere cylinders. These fingers are meant to grasp, and therefore appear to have flexible, heat-resistant rubber attached to them to prevent the fingers from dropping objects. In addition, the robot has a slide device allowing the arm to retract and draw an object inward immediately upon grasping it. Perhaps there might even be a sensor alerting the pilot that the robot has successfully grabbed the object. Giving that much consideration to the mecha's design will allow you to create a convincing, ingeniously drawn robot.

Chapter 3

Manual

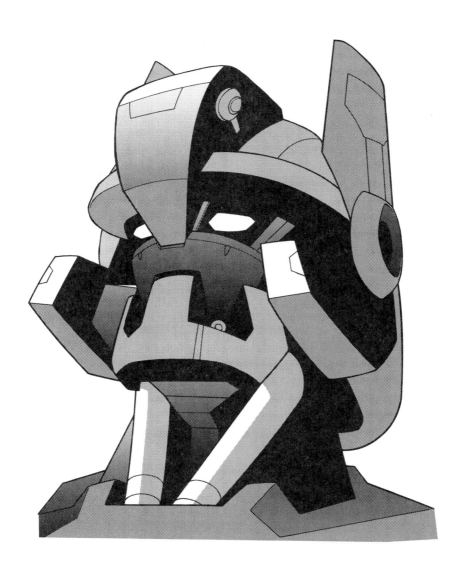

Chapter 1: Preliminaries

System Requirements
- Have installed at least one of the following:
 Adobe Photoshop 5.0/5.5/6.0/7.0/CS or Adobe Photoshop LE 5.0; Adobe Photoshop Elements
 1.0/2.0; Jasc Paint Shop Pro 7.0/8.0.

- Use one of the following operating systems:
 Microsoft Windows 98 SE, Windows ME, Windows 2000, or Windows XP.

- Meet or exceed the following hardware specifications:
 Intel Pentium or 100% compatible CPU (Pentium 3 800 MHz or higher recommended)
 CD-ROM drive
 128MB RAM or more (256MB or more recommended)
 250MB or more of free local disk space (950MB or more recommended)

 Adobe Photoshop Elements and Jasc Paint Shop Pro limit certain operations, and Computones'
 Autolayer functionality will not work with them. However, it is possible to manually create a new
 layer and lay it atop an image. For more details, consult the Software Functions Table on the next
 page. Further, there is no guarantee that this software will function perfectly with other
 Photoshop plug-in-compatible software packages that are not listed above.

1-2 Computones-Compatible Image File Formats
The image file formats Computones will and will not support are listed below.

Supported:
Grayscale
Duotone
RGB Color
CMYK Color
Lab Color

Not Supported:
Bitmap
Indexed Color
Multichannel
All 16 Bits/Channel modes

Chapter 2: Photoshop 5.0/5.5/6.0/7.0/CS

This chapter is for readers using Photoshop 5.0/5.5/6.0/7.0/CS.

Before You Install

These installation notes are for all supported operating systems (Microsoft Windows 98 SE, Windows Me, Windows 2000, or Windows XP).

• Make certain you have Photoshop 5.0, 5.5, 6.0, 7.0, or CS (hereafter "Photoshop") installed.

• Shut down any antivirus software or any other background applications, and adjust your operating system so that your machine does not go into sleep mode during installation.

Having multiple graphics software packages installed on the same machine can interfere with the normal use of this software.

Installing Computones

"Computones" is made up of a tone plug-in and a Computones-specific data set made up of tones. Follow the installation steps below in order to use them.

Step 1
Insert the Computones CD-ROM into a CD-ROM drive.

Step 2
Double-click on the My Computer icon on the Windows desktop (Windows XP users should click on the Start Menu and then click on My Computer), and double-click on the Computones CD-ROM icon. The Computones Installer.exe (or simply "Computones Installer") icon will appear. Double-click on it to start the installation.

Step 3
You will be asked to which folder or directory you want to install Computones. Select "Install in the Photoshop Plug-Ins folder." The installer will then automatically search for the plug-ins folder and install Computones.

Step 4

Next, install the Computones-specific tone data set.

If "Also copy tone files" is checked, then the plug-in, tone data, and tone sets on the CD-ROM will be selected and written to the local disk.

If "Also copy tone files" is not checked, then Tone and other utility programs will be installed, but every time you use the plug-in, the tone data and sets on the CD-ROM will need to be read from it.

If "Browse for tone file install location" is checked together with "Also copy tone files," then you can choose to which folder you will install the tone files.

Step 5

When you click on the Install button, you will be prompted to confirm the install folder. If everything is OK, then click on the Yes button and the installation will begin. If there is a problem with the selected folder, then click on the No button. You will then have to check "Browse for tone file install location" and manually specify the install folder. When you have done so, click on the OK button.

- In the following cases, Computones will not be able to automatically search for an install folder, and so you must check "Browse for tone file install location" and then manually specify the install folder. This will also be necessary if the error message shown here should appear at any other point.

1) The Photoshop Plug-Ins folder has somehow been changed.
 The installer will only search for the Plug-Ins folder inside the Photoshop install folder. In any other case, manually specify the install location.

2) There is more than one graphics software package installation.
 The installer will automatically search for the Photoshop install folder. If the folder it finds is not what you normally use, then manually specify the install folder for you do normally use for Photoshop.

3) The automatic search may fail for reasons not covered by the above. In such cases, manually specify the Photoshop folder.

Step 6

When you have confirmed the install folder and hit the OK button, if you have checked "Also copy tone files," then a dialog box titled, "Select installation files" will appear. This box will not appear if you have not checked this option, and you may proceed to Step 8. The list on the left side of the window will show the tone file groups present on the CD-ROM, while the list on the right shows the tone file groups to be installed. If there is some tone file group in the list on the right that you will not be using, select it from the list and hit the Remove button. When all the file groups you want have been added, click on the OK button.

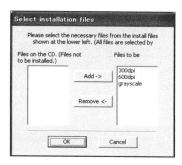

Step 7

If you have checked "Browse for tone file install location" and begun the installation, then you can choose where you wish to create the folder that will hold all the tone files. A dialog box will appear asking you about this; at that point, specify the folder as you wish. If you have not checked "Browse for tone file install location," then a tone file install folder will automatically be created within the plug-in install folder, and no dialog box will appear.

Step 8

Once the installation begins, a progress bar will be displayed. The installation may take some time, so if you are using a computer with a battery, please make sure you are also using an AC adapter when you install Computones. Hitting the Cancel button will stop the installation, and tone files in mid-installation will automatically be deleted. Once the installation is complete, a window will appear indicating so. Click on the OK button.

Step 9

After the installation is complete, launch Photoshop. If you select File → New... and create a new file, "Computones" will be displayed in the Filter menu. From there you can start using tones.

*If "Computones" is not displayed in the Filter menu, then it is possible that the folder in which the Plug-Ins reside and the plug-in install folder are different. You can check the location of the Plug-Ins folder at Edit → Preferences in Photoshop 6.0/7.0/CS (File → Preferences in Photoshop 5.0/5.5) under "Plug-Ins and Scratch Disks..."

Step 10

Once you have launched Photoshop, open the "Companion.psd" file located in the Sample folder on the Computones CD-ROM. Open the Filter menu and start up Computones. Immediately after startup, you will be asked just once for a serial number. Enter the serial number at the first of this book and click on OK.

Step 11

Installation is now complete.

Try Using Some Tones
Let's get started right away!

Step 1

Start Photoshop, access Edit → Preferences in Photoshop 6.0/7.0 (Files → Preferences in Photoshop 5.0/5.5), and select "General..." A new window will open, and in that window is an Interpolation pull down menu. Select "Nearest Neighbor (fastest)" in that menu and click on OK.

Step 2

Select File → Open...and an Open window will appear so you can select a file to read in. Open the Companion.psd file in the Sample folder on the Computones CD-ROM.

Step 3

Adjust the resolution of the sample image you opened in Step 2. Adjust it to match the resolution of the printer you are using such that one is an integral multiple of the other. For example, if you are using a printer capable of printing 720 dpi images, set your image resolution to be 360 or 720 dpi. If the horizontal and vertical printer resolutions are different (for example, 1440 x 720 dpi), then your image resolution should be a multiple of one or the other. In theory, a 1440 dpi resolution would be usable, but from a quality perspective it is too high. A lower setting is better.

To change the image resolution in Photoshop, click on Image → Image Size... A window will pop up; input a new value where the "600" is displayed in the Resolution field. Keep in mind the units are in pixels/inch.

- If you don't know the output capabilities of your printer, it does not matter if you leave the setting (600 dpi) as is, but printed copies of your image may look blurry as a result.

Step 4

Use Photoshop's Magic Wand Tool to select the collar area of the clothing on the figure in your sample image. We will call this selected portion the "Tone Draw Area." Now set the Magic Wand Tool's Tolerance value to 1, and uncheck Anti-aliased.

- Please consult your Photoshop manual for more on the Magic Wand and its option bar. Using tones without specifying a Tone Draw Area will automatically make the entire image the effective Tone Draw Area.

Step 5

Select Filter → Computones → Tone...

- If "Computones" does not appear in the Filter menu, please go back to the "Installing Computones" section and review the installation process.

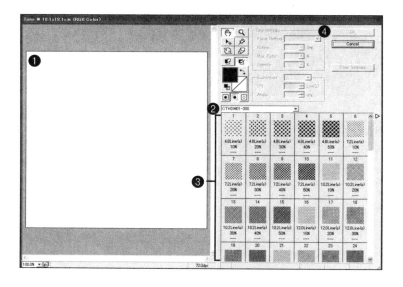

Step 6

In the middle of your screen, a Computones window will appear. At the left side of that window, there is a "Preview Display," and in it part of the image will be displayed at a 100% display ratio. ❶

Step 7

Click on the Tone Set Selection pull-down menu and select the "CTHDM01-600" tone set. The contents of the tone set are displayed at the bottom right in the Tone Set Area. ❷

- If you did not check the "Also copy tone files" box at installation, then every time you use tones they will be read directly from the Computones CD-ROM. Therefore, when you are using Computones you must make sure the CD-ROM is in the CD-ROM drive at all times.

Step 8

Try clicking on a tone you like from the Tone Set Area. We recommend you try out the "50.0 Line(s) 10%" dot tone. (If you don't see an exact match, choose a tone with similar values.) ❸

Step 9

Click on a tone, and it will cover the Tone Draw Area you specified in Step 4. If you would like to change tones, just click on another tone in the Tone Set Area.

- If you'd like to specify a different Tone Draw Area, then you have to go back to Photoshop first, and execute this process from Step 4 again.

Step 10

If you would like to apply the effects you have created to the sample image, then hit the OK button. After the tone you have selected has been applied, you will go back to Photoshop. If you print out your work, you can see the real results in more minute detail.

If you would rather not apply the effects you have created to the sample image, then click on the Cancel button. The sample image will be unchanged, and you will return to Photoshop. ❹

Chapter 3: Photoshop Elements 1.0/2.0

This chapter is for readers using Photoshop Elements 1.0/2.0.

Before You Install

These installation notes are for all supported operating systems (Microsoft Windows 98 SE, Windows Me, Windows 2000, or Windows XP).

- Make certain you have Photoshop Elements 1.0/2/0 (hereafter "Elements") installed.

- Shut down any antivirus software or any other background applications, and adjust your operating system so that your machine does not go into sleep mode during installation.

- Having multiple graphics software packages installed on the same machine can interfere with the normal use of this software.

Installing Computones

"Computones" is made up of a tone plug-in and a Computones-specific data set made up of tones. Follow the installation steps below in order to use them.

Step 1
Insert the Computones CD-ROM into a CD-ROM drive.

Step 2
Double-click on the My Computer icon on the Windows desktop (Windows XP users should click on the Start Menu and then click on My Computer), and double-click on the Computones CD-ROM icon. The Computones Installer.exe (or simply "Computones Installer") icon will appear. Double-click on it to start the installation.

Step 3
You will be asked to which folder or directory you want to install Computones. Select "Install in the Photoshop Plug-Ins folder." The installer will then automatically search for the Photoshop Elements plug-ins folder and install Computones.

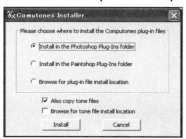

Step 4

Next, install the Computones-specific tone data set.

If "Also copy tone files" is checked, then the plug-in, tone data, and tone sets on the CD-ROM will be selected and written to the local disk.

If "Also copy tone files" is not checked, then Tone and other utility programs will be installed, but every time you use the tone data and sets on the CD-ROM they will need to be read from it.

If "Browse for tone file install location" is checked together with "Also copy tone files," then you can choose to which folder you will install the tone files.

Step 5

When you click on the Install button, you will be prompted to confirm the install folder. If everything is OK, then click on the Yes button and the installation will begin. If there is a problem with the selected folder, then click on the No button. You will have to check "Browse for tone file install location" and then manually specify the install folder. When you have done so, click on the OK button.

- In the following cases, Computones will not be able to automatically search for an install folder, and so you must check "Browse for tone file install location" and then manually specify the install folder. This will also be necessary if any of the error messages shown here should appear at any other point.

1) The Photoshop Elements Plug-Ins folder has somehow been changed.
 The installer will only search for the Plug-Ins folder inside the Photoshop Elements install folder. In any other case, manually specify the install location.

2) There is more than one graphics software package installation.
 The installer will automatically search for the Photoshop Elements install folder. If the folder it finds is not what you normally use, then manually specify the install folder you do normally use for Photoshop Elements.

3) The automatic search may fail for reasons not covered by the above. In such cases, manually specify the Photoshop Elements folder.

Step 6

When you have confirmed the install folder and hit the OK button, if you have checked "Also copy tone files," then a dialog box titled, "Select installation files" will appear. This box will not appear if you have not checked this option, and you may proceed to Step 8. The list on the left side of the window will show the tone file groups present on the CD-ROM, while the list on the right shows the tone file groups to be installed. If there is some tone file group in the list on the right that you will not be using, select it from the list and hit the Remove button. When all the file groups you want have been added, click on the OK button.

Step 7

Ilf you have checked "Browse for tone file install location" and begun the installation, then you can choose where you wish to create the folder that will hold all the tone files. A dialog box will appear asking you about this; at that point, specify the folder as you wish. If you have not checked "Browse for tone file install location," then a tone file install folder will automatically be created within the plug-in install folder, and no dialog box will appear.

Step 8

Once the installation begins, a progress bar will be displayed. The installation may take some time, so if you are using a computer with a battery, please make sure you are also using an AC adapter when you install Computones. Hitting the Cancel button will stop the installation, and tone files in mid-installation will automatically be deleted. Once the installation is complete, a window will appear indicating so. Click on the OK button.

Step 9

After the installation is complete, launch Photoshop Elements. If you select File →
New... and create a new file, "Computones" will be displayed in the Filter menu. From
there you can start using tones.

If "Computones" is not displayed in the Filter menu, then it is possible that the folder
in which the Plug-Ins reside and the plug-in install folder are different. You can check
the location of the Plug-Ins folder at Edit → Preferences under "Plug-Ins and Scratch
Disks..."

Step 10

Once you have launched Photoshop Elements, open the "Companion.psd" file located
in the Sample folder on the Computones CD-ROM. Open the Filter menu and start up
Computones. Immediately after startup, you will be asked just once for a serial
number. Enter the serial number at the first of this book and click on OK.

Step 11

Installation is now complete.

Let's get started right away!

Step 1

Start Photoshop Elements, select File → Open... and an Open window will appear so you can select a file to read in. Open the Companion.psd file in the Sample folder on the Computones CD-ROM.

- If you are unsure how to use File → Open..., please consult the Photoshop Elements manual.

Step 2

Adjust the resolution of the sample image you opened in Step 1. Adjust it to match the resolution of the printer you are using such that one is an integral multiple of the other. For example, if you are using a printer capable of printing 720 dpi images, set your image resolution to be 360 or 720 dpi. If the horizontal and vertical printer resolutions are different (for example, 1440 x 720 dpi), then your image resolution should be a multiple of one or the other. In theory, a 1440 dpi resolution would be usable, but from a quality perspective it is too high. A lower setting is better.

To change the image resolution in Photoshop Elements, click on Image → Image Size... A window will pop up; input a new value where the "600" is displayed in the Resolution field. Keep in mind the units are in pixels/inch, and in the lower part of the same window, "Resample Image" is set to "Nearest Neighbor."

- If you don't know the output capabilities of your printer, it does not matter if you leave the setting (600 dpi) as is, but printed copies of your image may look blurry as a result.

Step 3

Use Photoshop Elements' Magic Wand Tool to select the collar area of the clothing on the figure in your sample image. We will call this selected portion the "Tone Draw Area." Now set the Magic Wand Tool's Tolerance value to 1, and uncheck Anti-aliased.

- Please consult your Photoshop Elements manual for more on the Magic Wand and its option bar. Using tones without specifying a Tone Draw Area will automatically make the entire image the effective Tone Draw Area.

Step 4

Select Filter → Computones → Tone...

*If "Computones" does not appear in the Filter menu, please go back to the "Installing Computones" section and review the installation process.

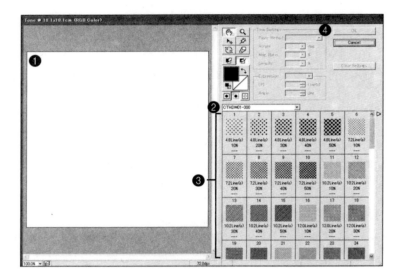

Step 5

In the middle of your screen, a Computones window will appear. At the left side of that window, there is a "Preview Display," and in it part of the image will be displayed at a 100% display ratio.❶

Step 6

Click on the Tone Set Selection pull-down menu and select the "CTHDM01-600" tone set. The contents of the tone set are displayed at the bottom right in the Tone Set Area.❷

*If you did not check the "Also copy tone files" box at installation, then every time you use tones they will be read directly from the Computones CD-ROM. Therefore, when you are using Computones you must make sure the CD-ROM is in the CD-ROM drive at all times.

Step 7

Try clicking on a tone you like from the Tone Set Area. We recommend you try out the "55.0 Line(s) 40%" dot tone. (If you don't see an exact match, choose a tone with similar values.)❸

Step 8

Click on a tone, and it will cover the Tone Draw Area you specified in Step 3. If you would like to change tones, just click on another tone in the Tone Set Area.

- If you'd like to specify a different Tone Draw Area, then you have to go back to Photoshop Elements first, and execute this process from Step 3 again.

Step 9

If you would like to apply the effects you have created to the sample image, then hit the OK button. After the tone you have selected has been applied, you will go back to Photoshop Elements. If you print out your work, you can see the real results in more minute detail.❹

If you would rather not apply the effects you have created to the sample image, then click on the Cancel button. The sample image will be unchanged, and you will return to Photoshop Elements.

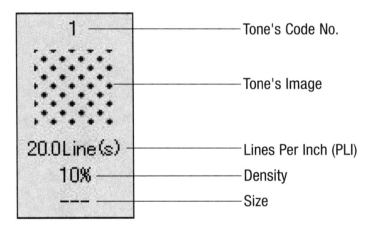

Tone's Code No.

Tone's Image

Lines Per Inch (PLI)

Density

Size

Chapter 4: Jasc Paint Shop Pro 7.0/8.0

This chapter is for readers using Jasc Paint Shop Pro 7.0/8.0.

Before You Install
These installation notes are for all supported operating systems (Microsoft Windows 98 SE, Windows Me, Windows 2000, or Windows XP).

• Make certain you have Jasc Paint Shop Pro 7.0/8.0 (hereafter "Paint Shop Pro") installed.

• Shut down any antivirus software or any other background applications, and adjust your operating system so that your machine does not go into sleep mode during installation.

• Having multiple graphics software packages installed on the same machine can interfere with the normal use of this software.

Installing Computones
"Computones" is made up of a tone plug-in and a Computones-specific data set made up of tones. Follow the installation steps below in order to use them.

Step 1
Insert the Computones CD-ROM into a CD-ROM drive.

Step 2
Double-click on the My Computer icon on the Windows desktop (Windows XP users should click on the Start Menu and then click on My Computer), and double-click on the Computones CD-ROM icon. The Computones Installer.exe (or simply "Computones Installer") icon will appear. Double-click on it to start the installation.

Step 3
You will be asked to which folder or directory you want to install Computones. Select "Install in the Paint Shop Pro Plug-Ins folder." The installer will then automatically search for the Paint Shop Pro plug-ins folder and install Computones.

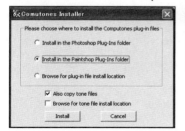
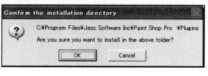

Step 4

Next, install the Computones-specific tone data set.

If "Also copy tone files" is checked, then the plug-in, tone data, and tone sets on the CD-ROM will be selected and written to the local disk.

If "Also copy tone files" is not checked, then Tone and other utility programs will be installed, but every time you use the plug-in, the tone data and sets on the CD-ROM will need to be read from it.

If "Browse for tone file install location" is checked together with "Also copy tone files," then you can choose to which folder you will install the tone files.

Step 5

When you click on Install, the installer will ask you to select the folder designated for Paint Shop Pro Plug-Ins if there are multiple folders present. If there is only one folder designated as such, then hit the OK button and the installation will begin. If there is some kind of problem with the install folder, then you will have to hit the No button, check the "Browse for tone file install location" box, and specify the folder manually. When you are done, hit the OK button.

Step 6

When you have confirmed the install folder and hit the OK button, if you have checked "Also copy tone files," then a dialog box titled, "Select installation files" will appear. This box will not appear if you have not checked this option, and you may proceed to Step 8. The list on the left side of the window will show the tone file groups present on the CD-ROM, while the list on the right shows the tone file groups to be installed. If there is some tone file group in the list on the right that you will not be using, select it from the list and hit the Remove button. When all the file groups you want have been added, click on the OK button.

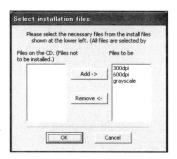

Step 7

IIf you have checked "Browse for tone file install location" and begun the installation, then you can choose where you wish to create the folder that will hold all the tone files. A dialog box will appear asking you about this; at that point, specify the folder as you wish. If you have not checked "Browse for tone file install location," then a tone file install folder will automatically be created within the plug-in install folder, and no dialog box will appear.

Step 8

Once the installation begins, a progress bar will be displayed. The installation may take some time, so if you are using a computer with a battery, please make sure you are also using an AC adapter when you install Computones. Hitting the Cancel button will stop the installation, and tone files in mid-installation will automatically be deleted. Once the installation is complete, a window will appear indicating so. Click on the OK button.

Step 9

After the installation is complete, launch Paint Shop Pro. If you select File → New... and create a new file, "Computones" will be displayed in the Filter menu. From there you can start using tones.

If "Computones" is not displayed in the Filter menu, then it is possible that the folder in which the Plug-Ins reside and the plug-in install folder are different. You can check the location of the Plug-Ins folder at Edit → Preferences under "Plug-Ins and Scratch Disks..."

Step 10

Once you have launched Paint Shop Pro, open the "Companion.psd" file located in the Sample folder on the Computones CD-ROM. Open the Filter menu and start up Computones. Immediately after startup, you will be asked just once for a serial number. Enter the serial number at the first of this book and click on OK.

Let's get started right away!

Step 1

Start Paint Shop Pro, select File → Open... and an Open window will appear so you can select a file to read in. Open the Companion.psd file in the Sample folder on the Computones CD-ROM.

- If you are unsure how to use File → Open..., please consult the Paint Shop Pro manual.

Step 2

Adjust the resolution of the sample image you opened in Step 1. Adjust it to match the resolution of the printer you are using such that one is an integral multiple of the other. For example, if you are using a printer capable of printing 720 dpi images, set your image resolution to be 360 or 720 dpi. If the horizontal and vertical printer resolutions are different (for example, 1440 x 720 dpi), then your image resolution should be a multiple of one or the other. In theory, a 1440 dpi resolution would be usable, but from a quality perspective it is too high. A lower setting is better.

To change the image resolution in Paint Shop Pro, click on Image → Resize... A window will pop up; check "Actual/print size" and input a new value where the "600.000" is displayed in the Resolution field. Keep in mind the units are in pixels/inch, and in the lower part of the same window, "Resize type" is set to "Pixel Resize."

- If you don't know the output capabilities of your printer, it does not matter if you leave the setting (600 dpi) as is, but printed copies of your image may look blurry as a result.

Step 3

After you click on the Magic Wand in the Tool palette, set the options in the Tool Options palette as follows:

1) Set the Match Mode to "RGB Value."
2) Set the Tolerance to 1.
3) Set Feather to 0.

- Please consult your Paint Shop Pro manual for more on the Magic Wand and its Tool Option palette.

Step 4

Use Photoshop Elements' Magic Wand Tool to select the collar area of the clothes on the figure in your sample image. We will call this selected portion the "Tone Draw Area."

*Using tones without specifying a Tone Draw Area will automatically make the entire image the effective Tone Draw Area.

Step 5

Select Effects → Plugin Filter → Computones → Tone...

*If "Computones" does not appear in the Plugin Filter menu, please go back to the "Installing Computones" section and review the installation process.

Step 6

In the middle of your screen, a Computones window will appear. At the left side of that window, there is a "Preview Display," and in it part of the image will be displayed at a 100% display ratio.❶

Step 7

Click on the Tone Set Selection pull-down menu and select the "CTHDM01-600" tone set. The contents of the tone set are displayed at the bottom right in the Tone Set Area.❷

*If you did not check the "Also copy tone files" box at installation, then every time you use tones they will be read directly from the Computones CD-ROM. Therefore, when you are using Computones you must make sure the CD-ROM is in the CD-ROM drive at all times.

Step 8

Try clicking on a tone you like from the Tone Set Area. We recommend you try out the "55.0 Line(s) 40%" dot tone. ❸

Step 9

Click on a tone, and it will cover the Tone Draw Area you specified in Step 4. If you would like to change tones, just click on another tone in the Tone Set Area.

- If you'd like to specify a different Tone Draw Area, then you have to go back to Paint Shop Pro first, and execute this process from Step 4 again.

Step 10

If you would like to apply the effects you have created to the sample image, then hit the OK button. After the tone you have selected has been applied, you will go back to Paint Shop Pro. If you print out your work, you can see the real results in more minute detail. ❹

If you would rather not apply the effects you have created to the sample image, then click on the Cancel button. The sample image will be unchanged, and you will return to Paint Shop Pro.

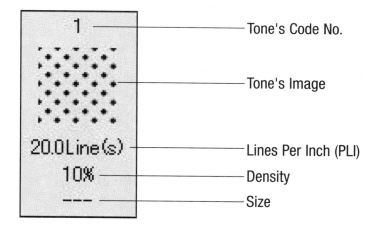

1 ——————————— Tone's Code No.

——————————— Tone's Image

20.0 Line(s) ——————— Lines Per Inch (PLI)

10% ——————————— Density

——— ——————————— Size

Uninstallation

Follow the steps below to uninstall Computones and completely remove it from your local disk.

Step 1

Insert the Computones CD-ROM into a CD-ROM drive.

Step 2

Double-click on the My Computer icon on the Windows desktop (Windows XP users should click on the Start Menu and then click on My Computer), and double-click on the Computones CD-ROM icon. The Computones Uninstaller.exe (or simply "Computones Uninstaller") icon will appear. Double-click on it to start the uninstallation.

Step 3

Next, a dialog box will appear. Choose an uninstallation method and hit the OK button.

"Remove only the plug-in folder"
This option removes the Computones plug-in itself only. The installed tone files stay as they are.

"Remove only the tone folders"
This option completely removes all the installed tone files. The plug-in file will remain, so the Computones plug-in will still be usable.

"Remove both the plug-in and tone folders"
This option completely removes all the installed plug-in and tone files.

Step 4

After starting the uninstaller, all the data covered by the option selected in Step 3 will be removed.

- If you install Computones more than once without uninstalling it, then only the most recently installed plug-in and/or tone files will be removed.

Step 5

If the uninstallation process completes normally, a message indicating so will appear. Hit the OK button.

- If the Computones installer was not used to install Computones, then an error message will appear. The same error will occur if you attempt to remove the tone folder when it does not exist on the local disk. In order to use the uninstaller, the Computones installer must have been used in the first place.

Tone Functions

The area selected via your graphic software determines the area in an image where a tone will be applied. If no such selection is made, then the tone will be applied to the entire image. For normal use, it is recommended that you first use your graphic software to select where in the image the tone is to be applied.

If your screen appears pink, it means that part of your image has been specified as a tone draw area. The actual draw area is the portion not shown in pink, but in white or gray.

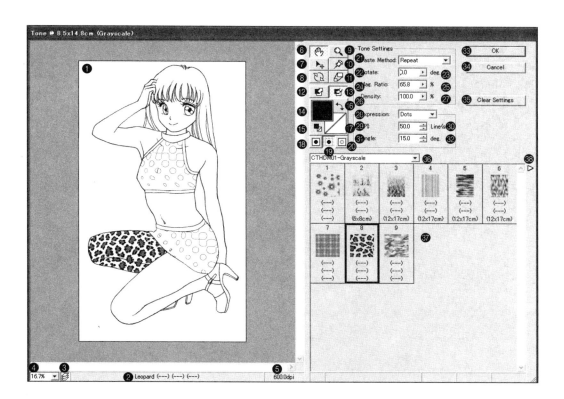

1) Preview Display

You can use this display to see how your image would look with a tone applied. You can use the scroll bars at the right and bottom of the display to scroll through the preview.

2) Selected Tone Info Area

The name, lines per inch (LPI), density, size, and other information on the tone currently applied to the Tone Draw Area are shown here. However, if the tone window is narrow, then all the information might not be displayed. Widening the window will reveal everything.

3) Preview Display Mode button

By turning this button on or off, you can display only the selected area ("Off") or you can display all possible layers, one on top of the other ("On").

• This function is not available in Paint Shop Pro.

4) Preview Display Ratio

Much like the Zoom Tool, clicking on this pull-down menu and then choosing one of the 13 choices inside it changes the display ratio of the image in the preview display. The choices are spread over 13 different steps between 5% and 800%, so you can zoom in or out on your image.

5) Image Resolution

This constant display shows the resolution of your image in dots per inch (DPI).

6) Hand Tool button

Clicking this button will start the Hand Tool, and the cursor will take the shape of a hand. You can use the hand tool to move the image around in the preview display. You can do the same thing with the scroll bars; however, they cannot move pins or applied tones separately.

7) Move Tool button

Hitting this button brings up the Move Tool, and the cursor will change into an arrowhead with four-way arrow. Using it in the preview display allows you to move a pin or an applied tone without moving the image itself.

8) Rotate Tool button

Clicking this button starts the Rotate Tool, and the cursor will change into a curly double arrow. Clicking and dragging on an image with this tool will rotate an applied tone around a pin.

9) Zoom Tool button

Hitting this button brings up the Zoom Tool, and turns your cursor into magnifying glass. You can use this tool to zoom in or out on the preview display over 13 steps, from 5% to 800%. Clicking on the preview display with the Zoom Tool icon as is will zoom in, while holding down the Alt key and clicking on it will zoom out.

10) Pin Tool button

Clicking on this button starts the Pin Tool, turning the cursor into a pin. The Pin Tool "pins" a tone down to a location of your choosing, and then serves as an axis around which you can rotate a tone. You can move the pin by clicking on the preview display; its default location is in the upper right corner of the image.

11) Scale Tool button

Hit this button to bring up the Scale Tool, and the cursor will turn into a double-ended arrow. You can then change the dimensions of an applied tone in all directions (centered on a pin) while maintaining the same image aspect ratio. Also, the magnification factor is indicated in a separate field; you can change this factor by directly entering a different value.

12) Use Host Color button

Hitting this button sets the foreground color to whatever color you are using in Photoshop or another host application, and renders the background transparent. If your Image Mode is set to Render Foreground and Background Colors, then the foreground color is set to transparent, and the background color will be set to whatever color you are using in your host application.

13) Use Custom Color button

If your Image Mode is set to Render Foreground and Background Colors when you press this button, then the foreground color will be rendered in 100% black, and the background color will be set to 100% white. If the Image Mode is set to Render in Foreground Color, then the foreground color will be set to transparent, and the background to 100% white.

14) Foreground Color Selection box

Clicking on this box will start up the Color Picker, and you can use it to change the foreground color. By doing so, you can also change the color of the tone you will be applying. The default foreground color is 100% black. If your Image Mode is set to Render in Foreground Color, the default is set to transparent.

- If you are unfamiliar with the usage of the Color Picker, please refer to your graphic software manual.

15) Restore Default Foreground and Background Colors icon

Clicking this icon sets the foreground color to 100% black and the background color to transparent. If you set the foreground or background colors to anything except 100% black, 100% white, or transparent, this icon will turn into a caution symbol.

16) Swap Foreground and Background Colors icon

Clicking this icon switches the foreground and background colors. You can produce black and white inversion effects this way.

17) Set Background Color box

Clicking on this box will open the Color Picker, and you can use it to change the background color. The default background color is transparent, but if your Image Mode is set to Render Foreground and Background Colors or Render in Background Color, the default is set to 100% white.

- If you are unfamiliar with the usage of the Color Picker, please refer to your graphic software manual.

18) Render Foreground and Background Colors button

Hitting this button will set the Image Mode to "Render Foreground and Background Colors." In Render Foreground and Background Colors mode, it is possible to color both the foreground and background. Each time you start using Tone, the foreground and background color settings will be as you left them the previous time.

19) Render in Background Color button

Hitting this button sets the Image Mode to Render in Background Color. In this mode the background color is set to transparent.

20) Render in Foreground Color button

Hitting this button sets the Image Mode to Render in Foreground Color. In this mode the foreground color appears transparent and is not visible.

21) Paste Method selection

You can choose how you apply a tone by choosing among the selections in this pull-down menu. For dot, line, and sand duotones, you can choose repeat or flip repeat. For radiating line and pattern duotones and grayscales, you can choose flip, flip repeat, don't repeat, no-flip repeat, and fold over.

22) Rotate field

Input a value in this field to rotate a tone as you wish. You can input any value from -360 degrees to 360 degrees in increments of 0.1 degrees. Inputting a value greater than 360 will result in the difference between that value and 360 being input. To enter the value after you input it, hit the Enter key or click anywhere on the tone. Hitting the Enter key twice will close the Tone window, so be careful.

23) Rotate Slide

You can also set a rotation angle by dragging the Angle Slide. The slide can move from -358 degrees to 358 degrees, in two-degree increments. The center, extreme left, and extreme right of the slide bar are set to zero degrees.

24) Magnification Ratio field

Entering a value in this field sets the magnification factor of your display. You can enter any value from 10% to 1000% in increments of 0.1%. To enter the value after you input it, hit the Enter key or click anywhere on the tone. Hitting the Enter key twice will close the Tone window, so be careful.

25) Magnification Ratio Slide

You can also set a magnification ratio by dragging the Magnification Ratio Slide. The slide can move from 10% magnification to 1000%, in 0.1% increments. The center of the slide bar is set to 100%. If you have specified a Tone Draw Area, then when you drag this slide the area will turn either white or gray, and the rest of the image will turn pink. To close the Magnification Ratio Slide, click anywhere outside the slide.

26) Density field

This field is only for grayscale tones. Entering a value in this field sets the density of a tone. You can enter any value from 20% to 180% in increments of 0.1%. To enter the value after you input it, hit the Enter key or click anywhere on the tone. Hitting the Enter key twice will close the Tone window, so be careful.

27) Density Slide

This field is only for grayscale tones. You can also set the density by dragging the Density Slide. The slide can move from 20% density to 180%, in 0.5% increments. The center of the slide bar is set to 100%. To close the Density Slide, click anywhere outside the slide.

28) Expression field

This field is only for grayscale tones. The choices of expression are None, Dots, Line, Cross, and Random. Choosing "None" will apply no dot shading.

29) LPI field

This field is only for grayscale tones; enter a lines per inch (LPI) value here as you like to apply dot shading. You can enter values from 1 to 85 in 0.1 increments. To enter the value after you input it, hit the Enter key or click anywhere on the tone. Hitting the Enter key twice will close the Tone window, so be careful. If you want to avoid "tone jumping," then you should specify 20 LPI for an image at 300 dpi or less, and 40 LPI for an image at 600 dpi or less.

• You must have something other than "none" selected in the Expression field in order to use this.

30) LPI Input button

This field is only for grayscale tones. You can specify the LPI value for applying dot shading to your selected grayscale tone at an angle of your choosing. Each click of the button steps through from 20 LPI to 27.5, 32.5, 42.5, 50, 55, 60, 65, 70, 75, to 80 LPI, displaying your image appropriately at each step. If you want to avoid "tone jumping," then you should specify 20 LPI for an image at 300 dpi or less, and 40 LPI for an image at 600 dpi or less.

• You must have something other than "none" selected in the Expression field in order to use this.

31) Angle field

This one is for grayscale tones only. You can specify the LPI value for applying dot shading to your selected grayscale tone at an angle of your choosing. You can input any value from -360 degrees to 360 degrees in increments of 0.1 degrees. We recommend that you normally use a 45-degree setting. To enter the value after you input it, hit the Enter key or click anywhere on the tone. Hitting the Enter key twice will close the Tone window, so be careful.

• You must have something other than "none" selected in the Expression field in order to use this one.

32) Angle adjustment buttons

These buttons are for grayscale tones only. By manipulating the upper and lower buttons, you can specify an angle as you like to apply dot shading. Each click of the button steps through from 0 degrees to 15, 30, 45, 60, 75, 90, 105, 120, 135, 150, and 165 degrees, displaying your image appropriately at each step. You will not be able to set this angle if you have "random" selected in the Expression field.

- You must have something other than "none" selected in the Expression field in order to use this one.

33) OK button

Hitting this button will set the tone and any modifications you have made onto your image, and return you to your graphic application. The parameters you set while using Tone will be remembered, and the next time you start it up they will be as you left them.

34) Cancel button

Hitting this button will cancel setting the tone and any modifications you have made onto your image, and return you to your graphic application. The parameters you set while using Tone will be remembered, and the next time you start it up they will be as you left them.

35) Clear Settings button

Pushing this button will reset any values you have changed to their defaults, which are as follows.
- Paste Method: Repeat, Angle: 0 degrees, Magnification: 100%, Density: 100%, Expression: Dot, LPI: 60, Angle: 45 degrees.

36) Tone Set Selection pull-down menu

This changes the tone set you wish to use. Click on this menu and select a tone set from those displayed. Then, by moving on to choose a tone set from among those in the tone set display, you can display its contents on your screen. A maximum of 20 sets within a single tone set can be displayed

- There may not be any tone set selections displayed in this field. In that case, proceed as follows:

 1. Create a new tone set by hitting the Menu button and using the "New Tone Set..." command.
 2. Import a tone set by hitting the Menu button, selecting Import Tone Set File, and saving a tone set as you wish..

37) Tone Information Display

When you select a tone from within the tone set display, a variety of information about that tone is displayed. In the Tone Information Display, from left to right, you will find the tone set index number, title, LPI, density, and size of the tone. Further, a "---" is displayed where no information is available or there is no need to display anything.

*About the tone information headings
The tone set index number is a number attached to every tone and displayed next to it in the tone set display. The numbers run from the top left tone across to the right and down, counting off each tone.

The title indicates some characteristic of a tone.

The LPI value shows how many lines of dots per inch make up a tone. For the most part, other than dot and line screens, most tones do not have this information, so nothing is displayed. Sand tones have an LPI value, but this is approximate.

Density is expressed as a percentage for each tone. A perfectly white tone has a 0% density, while a perfectly black one has 100%. A display of "100-0%" or "100-0-100%" means a given tone is a gradation.

Size is the length by width dimensions of a tone in centimeters. Tones with only a single value displayed are pattern tones with no boundary on either their width or length.

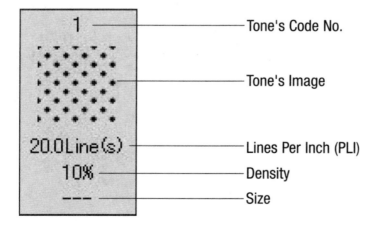

1 ——————————	Tone's Code No.
——————————	Tone's Image
20.0 Line(s) ——————	Lines Per Inch (PLI)
10% ———————	Density
--- ———————	Size

38) Menu button
Pressing this button brings up the Menu.

Supplement: Tone Set Registration and Building
If you did not check the "Also copy tone files" box at installation, the necessary tone files will not be on your local disk, meaning you cannot automatically register a tone set. The steps for manually registering and building a tone set are shown below.

❶ New Tone Set...
This command creates a new tone set on your local disk. You can use this command by selecting it from the tone set selection field, and you can create up to 1000 tone sets. When you use this command, a dialog box will appear, asking you to name your tone set. Once you've given it a name you like, click on OK to create a tone set. Click on the Cancel button to cancel the command.

❷ Rename Tone Set...
This command changes the name of the current tone set. Using it makes a dialog box appear asking you for a new tone set name. After you have entered a name you like, click on the OK button and the name will be changed. If you want to cancel the name change, hit the Cancel button.

❸ Delete Tone Set...

This command deletes the current tone set. However, the tones themselves will not be deleted and will remain on your local disk. Using this command will bring up a confirmation dialog box. If you wish to delete the tone set, click on Yes. If you do not, click on No.

❹ Import Tone Set File

This command imports a new tone set you would like to use and adds it behind the current tone set. Using this command brings up a submenu — click on View File. Another dialog box will appear to ask you where the next tone set you would like to import is located. Click on a tone set file (extension ".tst") and click on Open. If you want to cancel the import, click on Cancel. If you click on the list of previously added tone set files, you can choose a set from there as well.

- If you do not want to put the tone set you wish to import inside the tone set you are currently using, first use the Create New Tone Set command from the Menu to create a new set, and then import your desired tone set file to there.

❺ Add Tone File Folder...

Use this command to add all the tones in a folder you specify to the end of the current tone set in one stroke. Executing this command brings up a dialog box asking you for the location of the tone file folder. Choose the folder you wish and click on the OK button. If you wish to cancel the command, click on Cancel. Folders located inside the folder you specify can also be searched.

- Add Tone File...
 This command adds a single tone file to the end of the current tone set. Using this

command brings up a dialog box asking you for the location of the tone file you wish to add. Choose the ".tdt" file you wish and click on Open. If you wish to cancel the command, click on Cancel.

❻ Display Name
Using this command switches between displaying all tone names and displaying all tone thumbnails.

❼ Display Number
Using this command switches the display of all visible tone numbers on and off.

❽ Display LPI
Using this command switches the display of all visible tone LPI values on and off.

❾ Display Density
Using this command switches the display of all visible tone density values on and off.

❿ Display Size
Using this command switches the display of all visible tone sizes on and off.

Tone Set Display

This command displays the contents of the selected tone set at a glance. A total of 1200 tones, 6 across and 200 down, can be displayed at once. You can execute the following actions on a single tone therein:

Click: The selected tone is applied to the Tone Draw Area.

Double Click: Same effect as hitting the OK button after the selected tone is applied.

Ctrl + Drag: Moves the selected tone as you wish.

Selecting a Tone: Displays the tone's information in the tone information display area. This area will appear blank if the display area is not open.

Right Click: Opens up an embedded smaller menu with the following commands.

Add Tone File...

This command inserts a tone directly before the selected one. Using this command brings up a dialog box asking you for the location of the tone file you wish to add. Choose the ".tdt" file you wish and click on Open. If you wish to cancel the command, click on Cancel. Using this command to add a tone will shift all the following tone files' numbers, so care must be taken when importing tone palette files and the like.

Add White Space

This command inserts or adds a blank space after the selected tone set. Clicking on a blank allows you to reset the currently applied tone.

Select All

This command selects all of the tones loaded into the tone display area.

Insert White Space

This command inserts or adds a blank space directly in front of the selected tone. Clicking on a blank allows you to reset the currently applied tone. Using this command to add a tone will shift all the following tone files' numbers, so care must therefore be taken when importing tone palette files and the like.

Remove

Using this command removes only the selected tone from the tone set. The tone itself is not deleted from your local disk.

File Info...

Using this command displays a tone's full path in a new window. Click on OK to close it.

Using Shortcut Keys

Shortcut key combinations are available for the commands listed below.

Tone Shortcuts:
Spacebar → Hand Tool
Alt → Zoom Out
Ctrl → Zoom In
Alt + Spacebar → Rotate
Ctrl + Spacebar → Scale
Alt + Ctrl → Move
Alt + Ctrl + Space → Pin

Ctrl Shift Alt Space

Error Message Overview

The various Computones error messages are listed below. Should any others occur, as they are related to your operating system and/or graphic software, please consult the appropriate manual for a solution.

Error: Insufficient memory.
Cause: The PC does not have enough memory to run Computones
Solution: Shut down any other open applications or clear the internal memory in use by another graphic application to free up system memory and reserve it. (For more details, please see your graphic software manual.) If after this you still do not have enough memory, then you must increase the amount of physical system memory. The more internal system memory you have, the smoother Computones will operate.

Error: Incorrect serial number.
Cause: The serial number has not been input correctly.
Solution: You will only be asked once for the serial number. Check the number at the end of this book, make sure you have entered it correctly, and click on the OK button.

Error: Not a tone file.
Cause: You have specified a non-tone file for import.
Solution: Select a Computones-compatible tone file (.tdt).

Error: Not a tone set file.
Cause: You have specified a non-tone set file for import.
Solution: Select a Computones-compatible tone set file (.tst).

Error: Too many items. Cannot add to the tone set.
Cause: You are trying to add over 1002 tones to a single tone set.
Solution: A single tone set can hold a maximum of 1002 tones. To set or add more tones, use Menu → Create New Tone Set...

Error:	An error has occurred.
Cause:	Something other than the above has caused an error.
Solution:	Make sure you are using a Computones-compatible environment. Reboot your computer and attempt to continue. If the same error appears, try reserving system memory. If problems still persist, then uninstall Computones and try reinstalling it. If even after that you still get the same error, then there is probably some issue with your operating system.

Error:	An "X" is displayed in place of a tone file in a tone set, as shown in figure 1.
Cause:	A tone file that is specified within the tone set cannot be found. The file itself is not present, and only the file path has been retained. If the CD-ROM drive or the local disk label has changed, or if there has been some other change in the computing environment, then this problem can occur.
Solution:	Take the following steps. Select the tone in question, and then click on the following, in order: Menu → Delete Tone Set... → Yes → Create New Tone Set... → Input new tone set name → Import Tone Set File... → Browse Files... → Choose a tone set file → Open.

When the tone set is displayed as in figure 2 at the right, then the process is complete.

Question & Answer

Q How do I install Computones for Photoshop Elements 2?

A To install Computones for Adobe Photoshop Elements 2.0, follow the steps shown below.

1. Insert the Computones CD-ROM into a CD-ROM or DVD-ROM drive.

2. Double-click on the My Computer icon on the Windows desktop (Windows XP users should click on the Start Menu and then click on My Computer), and double-click on the Computones CD-ROM icon → Computones Installer.exe (or simply "Computones Installer").

3. You will be asked to which folder or directory you want to install Computones. Check the "Browse for plug-in file install location" radio button.

4. Choose a tone file install method, and click Install. A "Browse for Folder" dialog box will appear, allowing you to select the plug-in file install location. Click on the Local Disk (C:) → Program Files → Adobe → Photoshop Elements 2 → Plug-Ins. When you have selected the folder, click OK. If you have installed Photoshop Elements 2 to some other location, then select the Plug-Ins folder accordingly.

5. A "Confirm the installation directory" dialog box will appear. Check the file install location and click Yes to continue. If there is something wrong with the location, click No and repeat this process from step 3.

6. If you have checked the "Also copy tone files" box, then a "Browse for Folder" dialog box will appear. Add or remove tone files as you see fit, and click OK.

Once all installations are complete, an "Installation complete" dialog will appear. If the installation failed, repeat this process from step 2.

Q I cannot select any files to install, so I cannot install Computones!

A If during the Computones installation, the "Select installation files" dialog box has nothing displayed in the "Files to be installed" and "Files on the CD" lists, and you cannot continue with the installation, follow the steps shown below.

1. Insert the Computones CD-ROM into a CD-ROM or DVD-ROM drive.

2. Double-click on the My Computer icon on the Windows desktop (Windows XP users should click on the Start Menu and then click on My Computer), and double-click on the Computones CD-ROM icon → Computones Installer.exe (or simply "Computones Installer").

3. You will be asked to which folder or directory you want to install Computones. Check whichever radio button you like, uncheck "Also copy tone files," and click the Install button.

4. A "Confirm the installation directory" dialog box will appear. Check the file install location and click Yes to continue. If there is something wrong with the location, click No and repeat this process from step 3.

At this point the Computones plug-in and utility file installation is complete.

5. Next, install the tone files. Open up the Computones folder at its install location, create a new folder, and rename it "ToneFolder." You can verify the folder's install location in step 4 via the "Confirm the installation directory" dialog box.

6. Select the CTHDM01 folder on the Computones CD-ROM and choose one of the following methods to copy it to the Computones folder on your local disk.

 ❶ Right click on the CTHDM01 folder, and click on Copy from the pop up menu. Then right click on any blank space inside the Computones folder on your local disk and choose Paste.
 ❷ Drag the tone folders from the CD-ROM and drop them on some empty space inside Computones folder on your local disk.

7. The tone file installation is now complete. Next, start up Tones, click the Menu button, select Import Tone Set File → View File..., and import the tone file sets you just installed. If you copied tone set files that you do not need, use one of the methods below to remove them.

 ❶ If there are tones at certain resolutions you do not need, then put the entire 300 dpi or 600 dpi folders in the Recycle Bin to remove them.
 ❷ If there are certain tone genres you do not need, then open each resolution folder and place the Dot, Hatching, etc. folders in the Recycle Bin to remove them. Also remove tone set files like PT3-600-ALL.tst. that contain tones of all genres.

A "Cannot find the tone folder" message appears, and I cannot install Computones!

If during the Computones installation, a "Cannot find the tone folder" message appears, and you cannot continue with the installation, follow the steps shown below.

1. Insert the Computones CD-ROM into a CD-ROM or DVD-ROM drive.

2. Double-click on the My Computer icon on the Windows desktop (Windows XP users should click on the Start Menu and then click on My Computer), and double-click on the Computones CD-ROM icon → Computones Installer.exe (or simply "Computones Installer").

Question & Answer

3. You will be asked to which folder or directory you want to install Computones. Check whichever radio button you like, uncheck "Also copy tone files," and click the Install button.

4. A "Confirm the installation directory" dialog box will appear. Check the file install location and click Yes to continue. If there is something wrong with the location, click No and repeat this process from step 3.

At this point the Computones plug-in and utility file installation is complete.

5. Next, install the tone files. Open up the Computones folder at its install location, create a new folder, and rename it "ToneFolder." You can verify the folder's install location in step 4 via the "Confirm the installation directory" dialog box.

6. Select the CTHDM01 folder on the Computones CD-ROM and choose one of the following methods to copy it to the Computones folder on your local disk.

 ❶ Right click on the CTHDM01 folder, and click on Copy from the pop up menu. Then right click on any blank space inside the Computones folder on your local disk and choose Paste.
 ❷ Drag the tone folders from the CD-ROM and drop them on some empty space inside Computones folder on your local disk.

7. The tone file installation is now complete. Next, start up Tones, click the Menu button, select Import Tone Set File → View File..., and import the tone file sets you just installed. If you copied tone set files that you do not need, use one of the methods below to remove them.

 ❶ If there are tones at certain resolutions you do not need, then put the entire 300 dpi or 600 dpi folders in the Recycle Bin to remove them.
 ❷ If there are certain tone genres you do not need, then open each resolution folder and place the Dot, Hatching, etc. folders in the Recycle Bin to remove them.

Q A "Computones may not have been installed" message appears, and I cannot install Computones!

A If during the Computones installation, a "The main Computones application may not have been installed" message appears, and you cannot continue with the installation, follow the steps shown below.

1. Insert the Computones CD-ROM into a CD-ROM or DVD-ROM drive.

2. Double-click on the My Computer icon on the Windows desktop (Windows XP users should click on the Start Menu and then click on My Computer). Next, open the Plug-In folder for

whichever application to which you want to install Computones. If you have installed these folders to their default locations, they will be located as follows. The actual plug-in folder names may vary according to software package and version.

Adobe Photoshop 5.0/5.5/6.0/7.0/CS:
C:/Program Files/Adobe/Photoshop 5.0/Plug-ins
C:/Program Files/Adobe/Photoshop 5.5/Plug-ins
C:/Program Files/Adobe/Photoshop 6.0/Plug-ins
C:/Program Files/Adobe/Photoshop 7.0/Plug-ins
C:/Program Files/Adobe/Photoshop CS/Plug-ins

Adobe Photoshop Elements 1.0/2.0:
C:/Program Files/Adobe/Photoshop Elements/Plug-ins
C:/Program Files/Adobe/Photoshop Elements 2.0/Plug-ins

Jasc Paint Shop Pro 7/8:
C:/Program Files/Jasc Software Inc/ Paint Shop Pro 7/Plugins
C:/Program Files/Jasc Software Inc/ Paint Shop Pro 8/Plugins

If you have changed the default installation directories for these applications, then the Plug-In folders will not be located as above.

3. Open up the Plug-Ins folder, create a new folder in it, and rename it "Computones." Open that folder, and create two new folders inside it. Rename one "Computones" and the other "ToneFolder."

4. Open the PlugIn folder on the Computones CD-ROM, select the screentone.8bf file, and drop it into the Computones folder on the local disk.

5. Select the Computones folder on the Computones CD-ROM, and drop it into the ToneFolder folder. The tone file installation is now complete. Next, after starting Photoshop or whichever application you are using, start up Computones → Tones or Multi Tones, click on the Menu button, select Import Tone Set File → View File..., and import the tone file sets you just installed. If you copied tone set files that you do not need, use one of the methods below to remove them.

❶ If there are tones at certain resolutions you do not need, then put the entire 300 dpi or 600 dpi folders in the Recycle Bin to remove them.

❷ If there are certain tone genres you do not need, then open each resolution folder and place the Dot, Hatching, etc. folders in the Recycle Bin to remove them.

Question & Answer

Q I tried running the uninstaller, but I cannot remove Computones!

A If you used a drag-and-drop or copy-and-paste method to install Computones from the CD-ROM, then the ComputonesUninstaller.exe (or "Computones Uninstaller") may not work. In that case, follow the steps below.

1. Double-click on the My Computer icon on the Windows desktop (Windows XP users should click on the Start Menu and then click on My Computer). Next, open the Plug-In folder for whichever application from which you want to uninstall Computones. If you have installed these folders to their default locations, they will be located as follows. The actual folder names may vary according to software package and version.

 Adobe Photoshop 5.0/5.5/6.0/7.0/CS:
 C:/Program Files/Adobe/Photoshop 5.0/Plug-ins
 C:/Program Files/Adobe/Photoshop 5.5/Plug-ins
 C:/Program Files/Adobe/Photoshop 6.0/Plug-ins
 C:/Program Files/Adobe/Photoshop 7.0/Plug-ins
 C:/Program Files/Adobe/Photoshop CS/Plug-ins

 Adobe Photoshop Elements 1.0/2.0:
 C:/Program Files/Adobe/Photoshop Elements/Plug-ins
 C:/Program Files/Adobe/Photoshop Elements 2.0/Plug-ins

 Jasc Paint Shop Pro 7/8:
 C:/Program Files/Jasc Software Inc/ Paint Shop Pro 7/Plugins
 C:/Program Files/Jasc Software Inc/ Paint Shop Pro 8/Plugins

 If you have changed the default installation directories for these applications, then the Plug-In folders will not be located as above.

2. Select the Computones folder in your application's Plug-In folder and drag-and-drop it into the Recycle Bin, or right click on the folder and select Delete from the pop up menu. To completely remove the Computones folder, open the Recycle Bin, and select Empty Recycle Bin from the File menu, or right click on the Recycle Bin and select Empty Recycle Bin from the pop up menu.

Q When I apply a duotone to my image, it looks blurry!

A When you apply a duotone to an image and then display it at 66.6%, 33.3%, or any other magnification other than 100%, it can appear blurry or appear to be "tone jumping." This is due to Photoshop's image interpolation, and there is no actual blurriness present. If you wish to confirm this via your display, be sure to set your magnification factor to 100%.

Q When I print anything out on an inkjet printer, it looks blurry!

A The way inkjet printers print things, it is not possible to print dot patterns precisely as they appear. Also, it may be that the output resolution of the printer you are using and the resolution of the tones in your image are not compatible. This can cause significant blurring or tone jumping. In order to print clearly on an inkjet printer, you must adequately adjust the resolution settings of both the printer and your image.

Q What should I do to print clearly on an inkjet printer?

A If the resolution of the printer you are using and the resolution of the tones in your image are not compatible, blurring or tone jumping can occur. The way inkjet printers print things, it is not possible to print dot patterns precisely as they appear, but by adjusting the output resolution of your printer and the resolution of your image, you can improve print quality and bring it closer to your original work.

1. Verify the output resolution of your printer in your manual.

2. Open your original image in Photoshop. Create multiple working copies of your work for printing purposes.

3. Select Image → Image Size and an Image Size dialog box will appear. Check the Resolution value in the Document Size area. If one of the following conditions applies, proceed to step 4.

 *the inkjet printer resolution = the image resolution
 *the inkjet printer resolution = an even multiple of the image resolution
 *an even multiple of the inkjet printer resolution = the image resolution

If the above conditions do not apply, then your inkjet printer will interpolate the image according to its driver, and the blurriness and tone jumping in your printed image will be worse. In this case, check the Constrain Proportion and Resample Image boxes in the Image Size dialog box, and choose Nearest Neighbor from the Resample Image pull-down menu. Set the Resolution in the Document Size area to match your printer. If your printer's resolution is 1200 dpi or higher, then enter the printer resolution divided by 2 or 4.

4. Click the OK button to apply the current resolution settings, select File → Print..., and print the image. If there is a "Bidirectional Printing" option in your Print dialog, turn it off and then print your image. Leaving this option on may cause tone jumping.

Tone Collection Guide

Dot Tones

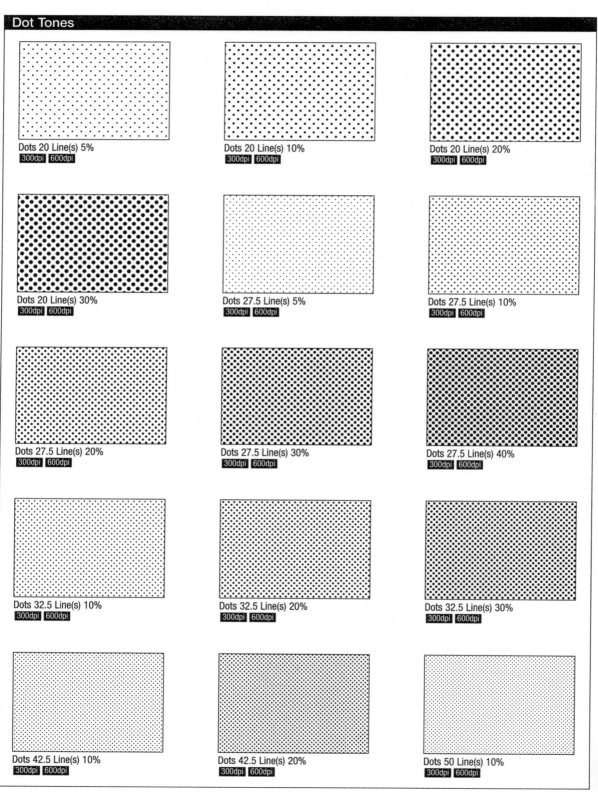

Dots 20 Line(s) 5%
300dpi 600dpi

Dots 20 Line(s) 10%
300dpi 600dpi

Dots 20 Line(s) 20%
300dpi 600dpi

Dots 20 Line(s) 30%
300dpi 600dpi

Dots 27.5 Line(s) 5%
300dpi 600dpi

Dots 27.5 Line(s) 10%
300dpi 600dpi

Dots 27.5 Line(s) 20%
300dpi 600dpi

Dots 27.5 Line(s) 30%
300dpi 600dpi

Dots 27.5 Line(s) 40%
300dpi 600dpi

Dots 32.5 Line(s) 10%
300dpi 600dpi

Dots 32.5 Line(s) 20%
300dpi 600dpi

Dots 32.5 Line(s) 30%
300dpi 600dpi

Dots 42.5 Line(s) 10%
300dpi 600dpi

Dots 42.5 Line(s) 20%
300dpi 600dpi

Dots 50 Line(s) 10%
300dpi 600dpi

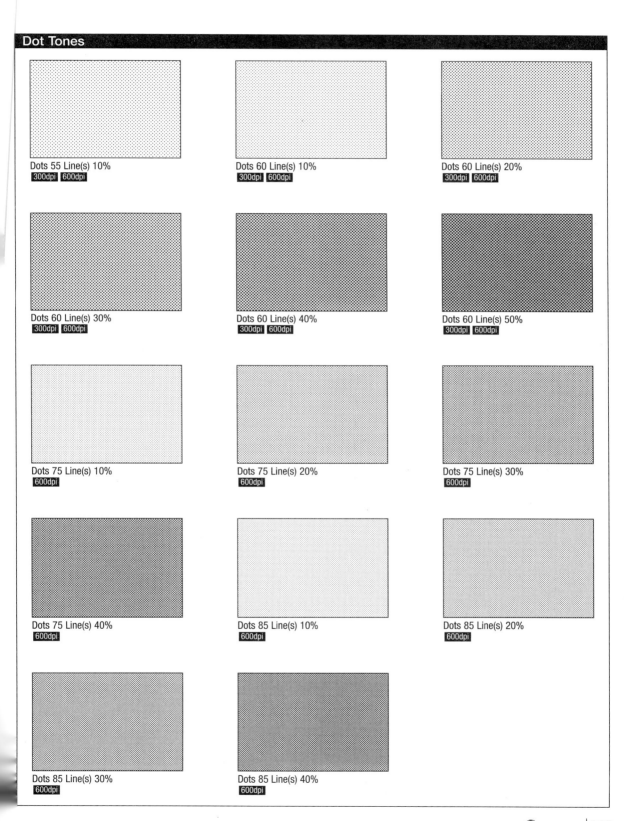

Dot Tones

Dots 55 Line(s) 10%
`300dpi` `600dpi`

Dots 60 Line(s) 10%
`300dpi` `600dpi`

Dots 60 Line(s) 20%
`300dpi` `600dpi`

Dots 60 Line(s) 30%
`300dpi` `600dpi`

Dots 60 Line(s) 40%
`300dpi` `600dpi`

Dots 60 Line(s) 50%
`300dpi` `600dpi`

Dots 75 Line(s) 10%
`600dpi`

Dots 75 Line(s) 20%
`600dpi`

Dots 75 Line(s) 30%
`600dpi`

Dots 75 Line(s) 40%
`600dpi`

Dots 85 Line(s) 10%
`600dpi`

Dots 85 Line(s) 20%
`600dpi`

Dots 85 Line(s) 30%
`600dpi`

Dots 85 Line(s) 40%
`600dpi`

Tone Collection Guide

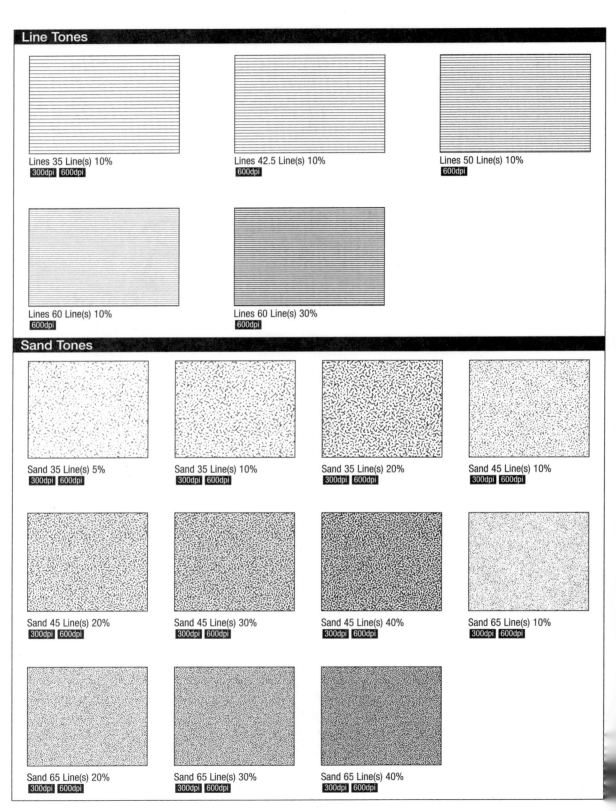

Line Tones

Lines 35 Line(s) 10%
`300dpi` `600dpi`

Lines 42.5 Line(s) 10%
`600dpi`

Lines 50 Line(s) 10%
`600dpi`

Lines 60 Line(s) 10%
`600dpi`

Lines 60 Line(s) 30%
`600dpi`

Sand Tones

Sand 35 Line(s) 5%
`300dpi` `600dpi`

Sand 35 Line(s) 10%
`300dpi` `600dpi`

Sand 35 Line(s) 20%
`300dpi` `600dpi`

Sand 45 Line(s) 10%
`300dpi` `600dpi`

Sand 45 Line(s) 20%
`300dpi` `600dpi`

Sand 45 Line(s) 30%
`300dpi` `600dpi`

Sand 45 Line(s) 40%
`300dpi` `600dpi`

Sand 65 Line(s) 10%
`300dpi` `600dpi`

Sand 65 Line(s) 20%
`300dpi` `600dpi`

Sand 65 Line(s) 30%
`300dpi` `600dpi`

Sand 65 Line(s) 40%
`300dpi` `600dpi`

Rendering Tones

Flash Effect L 01B
`300dpi` `600dpi`

Rendering L 04B
`300dpi` `600dpi`

Rendering L 06
`300dpi` `600dpi`

Speed Lines 01
`300dpi` `600dpi`

Speed Lines 03
`300dpi` `600dpi`

Rendering L 01
`300dpi` `600dpi`

Rendering L 04B2
`300dpi` `600dpi`

Rendering L 09B
`300dpi` `600dpi`

Rendering L 10B
`300dpi` `600dpi`

Rendering L 17
`300dpi` `600dpi`

Flash Fills 01A
`300dpi` `600dpi`

Flash Fills 05
`300dpi` `600dpi`

Flash Fills 11
`300dpi` `600dpi`

D Needles 02
`300dpi` `600dpi`

D Needles 06
`300dpi` `600dpi`

Needle Fills 01
`300dpi` `600dpi`

Needle Fills 02
`300dpi` `600dpi`

Needles 09-E
`300dpi` `600dpi`

Needles 17-C
`300dpi` `600dpi`

Tone Collection Guide

Gradation Tones

Dots Gradation / 40 lpi / 100% - 0% - 100% / 2cm
`300dpi` `600dpi`

Dots Gradation / 40 lpi / 100% - 0% - 100% / 6.6cm
`300dpi` `600dpi`

Dots Gradation / 40 lpi / 100% - 0% - 100% / 16.5cm
`300dpi` `600dpi`

Dots Gradation / 40 lpi / 100% - 0% - 100% / 33cm
`300dpi` `600dpi`

Dots Gradation / 60 lpi / 100% - 0% - 100% / 2cm
`300dpi` `600dpi`

Dots Gradation / 60 lpi / 100% - 0% - 100% / 6cm
`300dpi` `600dpi`

Dots Gradation / 60 lpi / 100% - 0% - 100% / 16.5cm
`300dpi` `600dpi`

Dots Gradation / 60 lpi / 100% - 0% - 100% / 33cm
`300dpi` `600dpi`

Dots Gradation / 65 lpi / 100% - 0% - 100% / 2cm
`300dpi` `600dpi`

Dots Gradation / 65 lpi / 100% - 0% - 100% / 6.6cm
`300dpi` `600dpi`

Dots Gradation / 65 lpi / 100% - 0% - 100% / 16.5cm
`300dpi` `600dpi`

Dots Gradation / 65 lpi / 100% - 0% - 100% / 33cm
`300dpi` `600dpi`

Sand Hatching Gradation 100% - 0% / 4.4cm
`300dpi` `600dpi`

Sand Hatching Gradation 100% - 0% / 16.5cm
`300dpi` `600dpi`

Sand Hatching Gradation 100% - 0% / 33cm
`300dpi` `600dpi`

Sand Hatching Gradation 100% - 0% - 100% / 2cm
`300dpi` `600dpi`

Sand Hatching Gradation 100% - 0% - 100% / 4.4cm
`300dpi` `600dpi`

Sand Hatching Gradation 100% - 0% - 100% / 16.5cm
`300dpi` `600dpi`

Sand Hatching Gradation 100% - 0% - 100% / 33cm
`300dpi` `600dpi`

Sand Hatching Gradation 40% - 0% 2cm
`300dpi` `600dpi`

Sand Hatching Gradation 40% - 0% 4.4cm
`300dpi` `600dpi`

Sand Hatching Gradation 40% - 0% 16.5cm
`300dpi` `600dpi`

Sand Hatching Gradation 40% - 0% 33cm
`300dpi` `600dpi`

Sand Hatching Gradation 40% - 0% - 40% 2cm
`300dpi` `600dpi`

Sand Hatching Gradation 40% - 0% - 40% 4.4cm
`300dpi` `600dpi`

Sand Hatching Gradation 40% - 0% - 40% 16.5cm
`300dpi` `600dpi`

Sand Hatching Gradation 40% - 0% - 40% 33cm
`300dpi` `600dpi`

Hatching Gradation 100% - 0% 3.3cm
`300dpi` `600dpi`

Hatching Gradation 100% - 0% 5.5cm
`300dpi` `600dpi`

Hatching Gradation 100% - 0% 8.25cm
`300dpi` `600dpi`

Hatching Sgl Cross
`300dpi` `600dpi`

Hatching Dbl Cross
`300dpi` `600dpi`

Lightning
`300dpi` `600dpi`

Explosion 02
`300dpi` `600dpi` `GLAY`

Explosion 04
`300dpi` `600dpi`

Explosion 06
`300dpi` `600dpi`

Explosion 07
`300dpi` `600dpi`

Volcanic Eruption
`300dpi` `600dpi`

Midair Explosion
`300dpi` `600dpi`

Sand Hatching CL02
`300dpi` `600dpi`

Lightning Rd Msk02
`300dpi` `600dpi`

Smoke
`300dpi` `600dpi`

Swl Smoke 01
`300dpi` `600dpi`

Rad Smoke 01
`300dpi` `600dpi`

Scorched Earth 01
`300dpi` `600dpi`

Scorched Earth 02
`300dpi` `600dpi`

Explosion 01
`GLAY`

Explosion 03
`GLAY`

Explosion 05
`GLAY`

Nova
`GLAY`

Cloud Lightning 01
`GLAY`

Lightning Rd 02
`GLAY`

Tone Collection Guide

Rain 02
GLAY

Deluge
GLAY

Parallel L FFlow
GLAY

Parallel L LFlow01
GLAY

Clouds 01
GLAY

Clouds 12
GLAY

Clouds 24
GLAY

Clouds 40
GLAY

Clouds 45
GLAY

Clouds 49
GLAY

Zebra Stripes
GLAY

Camo 01
GLAY

Camo
GLAY

Samekomon 5%
300dpi 600dpi

Samekomon 20%
300dpi 600dpi

Samekomon 30%
300dpi 600dpi

Samekomon 40%
300dpi 600dpi

Samekomon 50%
300dpi 600dpi